RAMPANT REALITY 1950-2000 FROM SALVADOR DALI TO JEFF KOONS

KUNSTHAUS ZÜRICH NOVEMBER 17TH, 2000-JANUARY 21ST, 2001 **HAMBURGER KUNSTHALLE** FEBRUARY 16TH-MAY 6TH, 2001

Published in conjunction with the exhibition HYPERMENTAL Rampant Reality 1950–2000. From Salvador Dalí to Jeff Koons

Kunsthaus Zürich 17th November 2000–21st January 2001 **Hamburger Kunsthalle** 16th February 2001–6th May 2001 **Idea and concept** Bice Curiger **Exhibition and catalog** Bice Curiger, Christoph Heinrich **Catalog design and typesetting** Trix Wetter, Simone Eggstein, Irène Hiltpold **Editorial assistance** Catherine Hug, Eva Frosch, Sabina Nänny **Translations** Pauline Cumbers (introductory chapters), Michael Eldred (text by Peter Weibel), Fiona Elliott (text by Bice Curiger), Catherine Schelbert (texts by Sibylle Berg, Gero von Randow) **English editing** Catherine Schelbert **Proof** Claudia Meneghini Nevzadi **Coordination and production** Sabina Nänny

Production Dr. Cantz'sche Druckerei, Ostfildern-Ruit, Published by Hatje Cantz Verlag, Senefelderstrasse 12, 73760 Ostfildern-Ruit, Germany, Tel. (0)711/44 05 0, Fax (0)711/44 05 220, www.hatjecantz.de, Printed in Germany **ISBN 3-906574-10-5** (Kunsthaus Zürich/Hamburger Kunsthalle) **ISBN 3-906574-11-3** (English Edition) **ISBN 3-7757-9064-0 Texts** © **2000** by Kunsthaus Zürich, Hamburger Kunsthalle, Hatje Cantz Verlag, Ostfildern Ruit, and the authors. All rights reserved. **Illustrations** © **2000** VG Bild-Kunst, Bonn, for the works of Marina Abramovič, Hans Bellmer, Louise Bourgeois, Erik Bulatov, Salvador Dalí, Marcel Duchamp, Valie Export, Katharina Fritsch, Richard Hamilton, Kim Sooja, Yves Klein, Piero Manzoni, Bruce Nauman, Meret Oppenheim, James Rosenquist, Niki de Saint Phalle, Jean Tinguely, Per Olof Ultvedt, and by the artists, their heirs or legal successors. Despite extended research it has not been possible to determine all the owners of copyrights. Upon notification, the publisher will of course render customary payment for legitimate claims. **All reproductions of works by Salvador Dalí** © Kingdom of Spain, universal heir of Salvador Dalí / ProLitteris, 2000, Zürich, © Gala-Salvador Dalí Foundation by appointment of the Kingdom of Spain, ProLitteris, 2000, Zürich **Cover** Glenn Brown, Böcklin's Tomb (After Chris Foss), 1998. **Available through** D.A.P. / Distributed Art Publishers, Inc., 155 Sixth Avenue, Second Floor, New York, New York 10013, Tel: (212) 627-1999, Fax: (212) 627-9484

Hypermental - Art with a Life of Its Own

So all the drawers of the huge storage cabinet have been opened–that cabinet filled with art from the last fifty years, faithfully preserved and neatly classified. And as if in a tale by Hans Christian Andersen, during the night the carefully kept works escaped from their time-honored places, cast off their tags and set out to find appealing companions: colleagues that one can exchange ideas with, kindred spirits, or sparring partners who will spark things off.

Liberated from historical categories, in *Hypermental,* the art of the last fifty years now has a chance to re-group. Individual works have never bothered whether they count as Photorealism, Neo-Expressionism, Viennese Aktionism, whether they are assigned to Pop or Op or Top Art, and the new configurations show just how much they have to say if for once they are let out of their pigeonholes. So works by Duchamp, Bourgeois, Kusama, and Barney meet up and talk of love–and of the burden love puts on the human body. Works by Hamilton, Dalí, Kruger, and Koons pool their experiences of the power of suggestion wielded by the media, which has become second nature to people over the last fifty years. Others by Nauman, Polke, Burden, and Matthew Ritchie make up a "house for modern man" in which the imaginable meets the unimaginable, from the tiniest particle to outer space. Four generations communicate with each other, and the point is not what the grandchildren have learnt from their grandfathers but what each individual work contributes to the bigger picture of the physical and mental condition of humankind on the threshold to the post-industrial age. The works of art shown in *Hypermental*, freed from their art-historical fetters, balance on that fine dividing line between reality and fantasy, between documentation and fiction, between allusion and delusion.

Of course individual artistic attitudes, the unmistakable positions of particular artists, will no doubt retreat into the background in this exhibition. The prevalent view that groups of works reveal more about an artistic stance than do single works has been set aside for a moment. Instead each work is taken seriously in its own right, in the confident belief that it will stand up as an individual–set free from its family bonds, as it were, and sent out into unfamiliar territory to find new relations, even if only for the duration of one exhibition.

The fact that reality is by no means the worst basis for art was discovered, or rather re-discovered, by artists in the 1960s. Since when art has tirelessly appropriated reality in ever new ways and has broken through the borders between observation and fantasy. Realism was always an interpretation of reality, but even so the artists of classical Surrealism were the first to evolve the instruments with which to explore the position of human beings caught between individual desires and the demands of society at large. The artists of the last forty years have reacted to the way that the second reality of the mass media is encroaching ever further into one's own personal and physical experiences, to the way that the flood of documentary and fictional images has engulfed individual lives.

The idea that the only real adventures take place in our heads is the premise of all poetry and has long since become common property. But now the daughters and sons of Western culture have become far from satisfied with merely looking within, so the leisure and entertainment industries devise more and more simulated adventures for mind and body to brave together. And yet art has always been able–has indeed chosen–to release adventures from their place in our minds and to have them continue inside other people's heads.

Acknowledgments

Numerous people have helped to realize this exhibition. Sabina Nänny, Catherine Hug and Eva Frosch have never flagged in their efforts. Trix Wetter and Simone Eggstein gave the catalogue its form and appearance. The participating artists provided the foundations without which this exhibition would never have been possible. They and the following museums, private collections and galleries have supported our exhibition with unstinting generosity:

Emanuel Hoffmann-Stiftung, Basel/Museum für Gegenwartskunst, Öffentliche Kunstsammlung, Basel/Staatliche Museen zu Berlin, Nationalgalerie, Berlin/Gala-Salvador Dalí Foundation, Figueres/Hamburger Kunsthalle/Onnasch Collection at the Hamburger Kunsthalle/Scharpff Collection at the Hamburger Kunsthalle/Herning Kunstmuseum, Denmark/Museo Nacional Centro de Arte Reina Sofía, Madrid/Fondation Cartier pour l'art contemporain, Paris/Yves Klein Archives, Paris/Salvador Dali Museum, St. Petersburg, FL/Moderna Museet, Stockholm/Generali Foundation, Vienna/Kunstmuseum Winterthur, Switzerland/migros museum für Gegenwartskunst, Zurich/Kunsthaus Zürich. Collection of Ruedi Bechtler/Daros Collection/The Estate of Ana Mendieta/Falckenberg Collection/Flick Collection/Collection of Patrick Frey/Goetz Collection, Munich/Hauser & Wirth Collection, St. Gall, Switzerland/Hildebrandt Collection, Hamburg/Collection of Hilton Als, New York/Collection of Jasper Johns/Collection of Pamela and Richard Kramlich/Olbricht Collection/Onnasch Collection/Raschdorf Collection/Mariella Collection, Genoa, Italy/Collection of Marita March/Collection of Claudine and Jean Marc Salomon/Collection of Rudolf and Ute Scharpff, Stuttgart/Collection of Nell and Jack Wendler, London/Zellweger Luwa AG Collection, Uster, Switzerland. Arndt & Partner, Berlin/Clara Maria Sels Gallery, Düsseldorf/Art & Public, Pierre Huber, Geneva/1000 Eventi Gallery, Milan/Marianne Boesky Gallery, New York/Cheim & Read, New York/Casey Kaplan Gallery, New York/Sean Kelly Gallery, New York/Galerie Lelong, New York/Robert

Miller Gallery, New York/The Project, New York/303 Gallery, New York/Ubu Gallery, New York/Thea Westreich Art Advisory Services, New York/Anne de Villepoix Gallery, Paris/Pièce Unique Gallery, Paris/Ota Fine Arts, Tokyo/Thomas Ammann Fine Art, Zurich/Ars Futura Gallery, Zurich/Hauser & Wirth Gallery, Zurich/Renée Ziegler Gallery, Zurich.

We also take this opportunity to thank those lenders who do not wish to be named and The British Council. In addition we wish to extend our gratitude to all of the artists represented in this exhibition well as the following people who contributed to the success of this project through interesting conversations, helpful hints, or important contacts:

Doris Ammann, Thomas Ammann Fine Art, Zurich; Arndt & Partner, Berlin; Ruedi Bechtler, Herrliberg, Switzerland; Bruno Bischofberger Gallery, Zurich; Mary Boone Gallery, New York; Wendy Williams, Jerry Gorovoy, Louise Bourgeois Studio, New York; Isabel Braga, Museu Serralves, Porto; Elisabeth Bronfen, Zurich; This Brunner, Zurich; Dominique Bürgi, Berne; Luis Campaña Gallery, Cologne; Gisela Capitain Gallery, Cologne; Sadie Coles HQ, London; Ina Contzen, Staatsgalerie Stuttgart; Deitch Projects, New York; De Pury & Luxembourg Art SA, Geneva; Konrad Fischer Gallery, Düsseldorf; Fotohof, Salzburg; Gebauer Gallery, Berlin; Michel Girardin, Zurich; Barbara Gladstone Gallery, New York; Marian Goodman Gallery, New York; Hans Hammarskiöld, Stockholm; Nic Hess, Zurich; Jerwood Gallery, London; Jasper Johns, New York; Jay Jopling, Irene Bradbury, Zoe Morley, White Cube, London; Barbara Mosca, Bern; Claudia Jolles, Zurich; Jeff Koons Studio, New York; Lisson Gallery, London; Eva Meyer-Hermann, Flick Collection; Metro Pictures, New York; Joshua Holdeman, Robert Miller Gallery, New York; Klosterfelde, Berlin; Sabine Knust, Maximilian Verlag, Munich; Iris Maczollek, Petr Nedoma, Galerie Rudolfinum, Prague; Rolf Ricke Gallery, Cologne; Matthew Marks Gallery, New York; Patrick Painter, Inc., Santa Monica; Giuseppe Pero, 1000 Eventi Gallery, Milan; Hauser & Wirth & Presenhuber Gallery, Zurich; Cay Sophie Rabinowitz, New York; Maria Reinshagen, Christie's, Zurich; T. Marshall Rousseau, Salvador Dali Museum, St. Petersburg, FL; Andrea Rosen Gallery, New York; Theo Ruff, Zurich; Reiner Ruthenbeck, Ratingen, Germany; Rainald Schumacher, Goetz Collection, Munich; Arturo Schwarz, Milan; Monika Sprüth Gallery, Cologne; Staatliches Museum, Schwerin; Philip Ursprung, Zurich; Ronny van de Velde, Antwerp; Robin Vousden, Anthony D'Offay Gallery, London; Cornel Windlin, Zurich.

We are deeply grateful to all our many well-wishers. Zurich, October 2000. Bice Curiger and Christoph Heinrich

Table of Contents

HYPERMENTAL
THE ESSAYS

THE REALITY COCKPIT

"In the 1950s we became aware of the possibility of seeing the whole world, at once, through the great visual matrix that surrounds us; a synthetic, 'instant' view."
Richard Hamilton, 1969

Bice Curiger

The prefix 'hyper' points to exaggeration, exaltation, to something distinctive. The only question is, distinct from what? Is the mental, intellectual realm—in which the rational and the irrational, the objective and the subjective freely mingle and mix together—a measurable phenomenon conforming to certain norms? Is there a yardstick marked 'mental' as opposed to the 'hypermental' traits we find here in works of art from a good five decades?

The question is based on a false premise, for is not exaggeration now the norm? But how did this happen, and since when have we been able to discern that we are caught up in a state of 'hypertension'?

The point at issue here is not heady intellectualism but rather a diffuse zone that has evolved somewhere between consciousness and the world, a zone that took shape and developed an increasingly strong gravitational force in direct proportion to the degree to which reality—as they say—started to multiply into its constituent parts and to vaporize. It is in this mental realm that all relationships are formed, the relationships a person has to other people, to things, organizations and systems. Here the reality of life connects directly with the virtual, the reflective and the instinctive, the situative and the prospective. And this realm is an elusive place in which the influences, deposits and patterns that determine and affect our collective lives manifest themselves, albeit in pictures—at least in the works of art presented here.

Thus in this exhibition works of art are not primarily viewed in terms of historical style or periodization, nor is there a desire to home in on art-historical landmarks; instead we have put our trust in the fact that outstanding art speaks across the ages and that—released from hackneyed modes of presentation—complex structures and forms of this kind cannot but gain from entering into new alliances with other works.

Six chapters provide a framework for the exhibition and the catalog. They lead the way into whole 'universes'—the world of objects and commercial goods; the friction between art, life and reality; eros, sexuality and psychology; science and the massive technological changes that constantly affect our lives. But all the time this boundless panorama is grounded by the individual works of art through the power of the sensual and by their being rooted in concrete reality, as lived and reflected by the various artists.

In every work of art it is possible to discern a horizon illuminated by the history of ideas and mentalities. But the art of the present and the cultural debates of the past decades invite us to take a fresh—occasionally even 'anthropological'—look at the history of art over the last fifty years. Take, for

instance, the impact of feminism which has irrevocably changed and influenced our perceptions and conclusions: this must now be taken into account when we look at fantasies and constructs of reality, as must findings regarding the effects of our 'media society' or the philosophical discourse surrounding the postmodern subject.

Unfamiliar confrontations between works from different epochs and decades, and the focused presentation of art as an integral part of a radically changing modern world will—ideally—return to the exhibits something of their once disturbing power.

The exhibition *Hypermental* shows art that relates to the actuality—the reality—of life. A reality that has acquired a particular lucidity having been progressively potentiated over the last hundred years both materially (by science) and in terms of ideas (by psychology). As a consequence we have become increasingly aware of how human beings relate to things imagined or virtual, to the output of the media, and hence also to delusions, mechanisms of perception, and the actuality within our own heads.

By the end of the Second World War at the latest, 'realism' had had its day. It had started to smack of naiveté and apparently served solely to illustrate ideological issues ranging from the harmless to the outright dangerous. All the more so when the world was swept by a real uprising in the name of the 'Great Abstract' which displayed an autonomous reality of its own, detached from the actuality of everyday life. Nevertheless certain movements in the art world still somehow clung to the notion of 'realism' as in Nouveau Réalisme, Hyperrealism and Photorealism, and in the short-lived *Demonstration for Capitalist Realism* by Richter and Lueg in 1963 (see p. 76).

In these movements as in Pop Art, reality—that loud, new reality of everyday life—returned to art and there was talk of Neo Dada. Art debate at the time was oriented towards the art-internal, self-legitimating continued pursuit of modernity. It was only gradually that deep-rooted cultural changes made their presence felt and fundamentally destabilized the hitherto clear, straightforward contrasts between public and private, individual and collective, objective and subjective. And certain artistic positions which had previously counted as affirmative now turned out to have a hidden core of cultural critique.

After the war figures like Jackson Pollock embodied the need for a tabula rasa, for radical change and a new start. Marcel Duchamp, whose works had scarcely been seen until well into the 1960s,[1] now became a key figure forming a bridge between the avant-garde in the early years of the century and its later manifestations. In his intellectual-alchemical, gender-analytical art praxis Marcel Duchamp is as important a point of reference for *Hypermental* as Salvador Dalí.

In the super-charged arena of art and consciousness it has become clear that our media-oriented society is continually producing hyperrealities—for all the world as though Dalí's "paranoiac-critical method" had long since become a ubiquitous, collective hallucination ritual. Surrealism not only revolutionized the notion of the ego and of reality, it also sowed the seeds of the renunciation of traditional art media, replacing these with collage, newspaper pictures and photography as the dominant instruments, the materials and 'immaterials' of a dawning new era.

Less concerned with the individual psyche and the mechanisms of the subconscious, artists today above all focus in their researches on collective influences, the conditioning of a 'second' psychic reality that is now regarded as 'natural', and on our penetration into hitherto unexplored virtual worlds.

The Surrealists stressed the existence of a psychic reality as opposed to a rational concept of what is real that had become impossibly narrow. While André Breton

SALVADOR DALI THE EYE, 1945
Oil on board, 23 x 33"/58.5 x 84 cm
One of the works Dalí produced for
Hitchcock's film *Spellbound*.

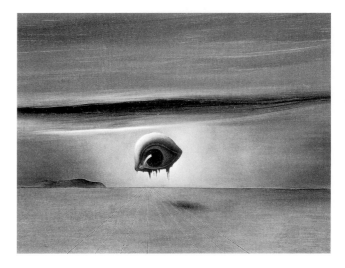

insisted in his first Surrealist manifesto that creative work should be free of any kind of rational control or aesthetic or moral constraints, Salvador Dalí's paranoiac-critical method is closer to art praxis today in that it makes provision for an observing agent that takes action and passes on and works through the impulses it receives. "Like Lacan, Dalí took a holistic approach, according to which the irrational already exists as a latent, space-time *totum* and is merely activated by our capacity for paranoia."[2]

In the same sense that Rosalind Krauss, in an enlightening essay on surrealist photography, showed that "the experience of *reality as representation* is at the core of surrealist thinking,"[3] Salvador Dalí used his "painterly eye" as his own personal state-of-the-art camera. The fascination of Dalí's painting today is that with its love of detail and its 'hyper-realism' *avant la lettre* it aspires to achieve a totality of space and time; equally compelling is the abandon with which it also sets itself apart from all the various advanced painterly movements of the day, as though out to cauterize the conventions of good taste

Some years ago Pipilotti Rist declared that "our eyes are 'blood-propelled' cameras."[4] In 1941 Dalí made a similar comparison: "I bear with me a precious apparatus which I invented two months ago and by means of which I will realize the greater part of my new pictures. Rather than a horrible, hard and mechanical photographic apparatus, it resembles a minuscule and tender apparatus of television in color. But the most wonderful thing! It is entirely soft! . . .Yes! An eye!"[5]

In 1958 Salvador Dalí produced the first raster painting in the history of art, *The Sistine Madonna or Madonna Ear,* now in the Metropolitan Museum, New York. A raster from a newspaper photo extends across the picture surface as an all-over depicting a gigantically enlarged ear inside which we see the Sistine Madonna; meanwhile in the left corner, in homage to the Hyperrealists of the past, a trompe l'oeil of an unfolded piece of paper appears to be floating in front of the picture.

Salvador Dalí's researches into perception and optical illusions are surrounded by an atmosphere of fevered fluidity. And it is not only his use of the newspaper raster, it is also this world of fluid motion and analytical observation that links Dalí with the later Sigmar Polke, whose artistic investigations take just as sharp a micro and macro view of the universe, the atoms within it, physics, and the history of humankind. One word sums up the special quality of both these artists: universality. Not as in Renaissance Man but a 20th and 21st century universality for the seeing person and the paranoiac alike, whose intelligence finds itself at an

SALVADOR DALI LA MADONE DE SIXTINE OU L'OREILLE DE LA MADONE/THE SIXTINE MADONNA OR MADONNA EAR, 1958
Oil on Canvas, 87¾ x 190¾"/223 x 190 cm
Metropolitan Museum New York

interface of many different forces, aware that it can never rationally penetrate the whole or the totality of anything.

"The experience of reality as representation" also permeates sculpture and art objects. Thus Duane Hanson's *Policeman and Rioter*, 1967, bears its own photographic optics within it—as a three-dimensional photographic "moment décisif" (Cartier Bresson), as a transfixed reportage photograph, a ghostly icon, a sculpture of a human being, reminiscent of the pictures in the legendary exhibition celebrating humanism in photography, *The Family of Man* (1955, presented by Edward Steichen in the Museum of Modern Art, New York). But sculpture of this kind does not invite us to indulge in conciliatory contemplation and transcendental flights. Rather we are faced with an endpoint, the paralysis that tends to be the outcome as much of our accusatory drive as of our perceptive faculties snatching at the photographic *momentum.*

In *Woman in Tub*, 1988, Jeff Koons transferred a popular postcard image into the third dimension. The result is a shameless amalgam—as though Duchamp's readymade had undergone a transformation in the lower reaches of taste only to emerge with a new life-affirming strength. And as it is raised into the third dimension—and into Duchamp's fourth dimension, namely eros—it becomes surprisingly palpable.

Could it be that Koons's headless woman was intended as an embodiment of Max Ernst's *Femme 100 têtes* from his famous surrealist collage of 1927, pointing prophetically to the way that the individual today is locked into the 'irrationally' colliding torrent of pictures produced by the media-led reality of modern life? Artists like Jeff Koons—or Richard Hamilton before him—take this abstract, ceaseless flow of 'matter' and create pictures that memorably capture the quintessence of the culture of their day. *Just what is it that makes today's homes so different, so appealing?*, was the question Richard Hamilton asked in his collage of Pop icons in 1956, where a cinema façade can be seen beyond the new home and where the ceiling is replaced by a moonscape. This study of an interior succinctly points to the themes of the future where man and woman as a gender-hyped species and in love with themselves seem to be formulating a 'modern' view of gender relations, the distinction between public and private, the version of reality perpetrated by the media (the tape recorder is the third protagonist in the picture).

The cultural conditioning of human consciousness, the experiments in carefully steered projections, have also been a concern of later artists such as Richard Prince who re-photographed the Marlboro Man and showed him to be a telling, irreal-real reference point, an iconographic model that has no trouble staking his predictable claim anywhere in the world.

Traditionally interiors have been seen as the domain of the woman. For Louise Bourgeois this has always included the way we inhabit our own bodies. In her artistic work she seems to be calmly uncovering things, revealing hitherto unrecognized laws. The numerous women who have at last turned their hands to artistic work are carried by that energy that goes with recognition. From muse and model to independent players in the art world: Meret Oppenheim's own life reflects this topos in the history of art in the 20th century, and in many of her works she plays freedom out against non-freedom, locating herself in minimal gestures in her own place between society, nature, and the cosmos.

In 1979 Robert Gober constructed and then set alight a model of his childhood home. Elsewhere in a photograph we see him in a wedding dress symbolizing the promise of institutionalized happiness, like an absurd house that he is trying out for a while. It is now clear that the Western house has become somewhat crumbly, but also open to the winds of change. While Hans Belting writes today about the placeless person who has him/herself become the "locus of the picture"[6] we cannot help but be amazed at the wild, humorous optimism of *Hon* (She), that walk-in sculpture/exhibition hall by Niki de Saint Phalle, Jean Tinguely, and Olof Ultveldt, which they constructed in the Moderna Museet in Stockholm in 1966. Photographs of the work show a queue of people waiting their turn to walk into the lap of the giant woman and to contemplate art (see p. 71).

Old images connect with new ones and vice versa. The artists themselves, with their special sensory faculties, espy the parameters for such explosive combinations and work out the necessary stratagems. During the many new initiatives of the 1960s, when the desire for friction and transformation

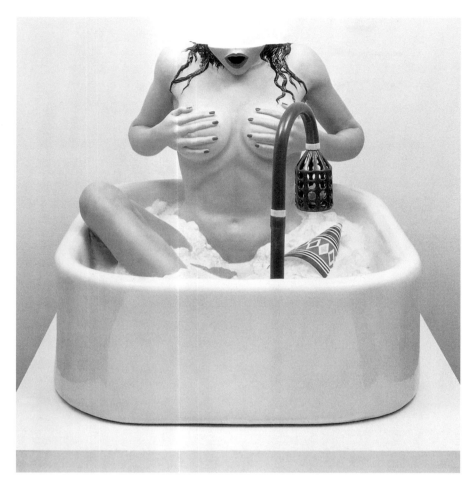

JEFF KOONS WOMAN IN TUB, 1988
Porcelain, 24³⁄₈ x 35⁷⁄₈ x 27¹⁄₈"
62 x 91 x 69 cm

led to Actions and 'Live in Your Head' events,[7] certain images loomed into public view that inspired dismay (Chris Burden, who had someone else shoot him in the arm) or perhaps even fear (Valie Export, who led her artist-partner through the town on all fours like a dog) or laughter or confusion (artists sitting on an upholstered suite in a furniture store as a demonstration of Capitalist Realism).

And when Damian Hirst goes into a morgue to lay his scandalously grinning head next to the head of a corpse and has his photograph taken, or when Sarah Lucas precisely pinpoints the signals of social deprivation and then employs down-to-earth humor to search these for truths that have, if possible, not yet been explained to death, we find emotional distance coupled with visual directness—informed involvement in real life, evidently directed from that place referred to at the outset of this essay, inside our minds: the cockpit from which we negotiate reality.

And it is from here that directions are repeatedly sent out to exorcize art, to rid it of its propensity for fanciful, tasteful innocuousness.

Anyone who takes art seriously as a finely tuned mental tool will readily credit its products with containing more than the relevant parties can ever explain at any one time.

1) The first monograph on Duchamp appeared in 1959. The first retrospective of his work took place in 1963 in the Pasadena Museum when Duchamp was 76 years old.
2) Karin v. Maur, in: *Salvador Dalí,* exh. cat., Staatsgalerie Stuttgart and Kunsthaus Zürich, 1989, p. XXXIII.
3) "The Photographic Conditions of Surrealism," in: Rosalind Krauss, *The Originality of Avant-Garde and Other Modernist Myths,* Cambridge, Mass., 1986, pp. 87-118.
4) See exh. cat., Kunstmuseum St. Gallen, 1994, pp. 6/7.
5) Salvador Dalí in exh. cat., Arts Club of Chicago, 1941, as cited by Dawn Ades in: *Dalí's Optical Illusions,* Wadsworth Atheneum Museum of Art, Hartford, Connecticut, 2000, p. 15.
6) Hans Belting, "Der Ort der Bilder." in: Hans Belting / Lydia Haustein (eds.) *Das Erbe der Bilder,* Munich, 1998, pp. 34 ff.
7) Subtitle of the legendary exhibition *When Attitudes Become Form* in the Kunsthalle Bern, 1969/70.

The Unfinished Project of Surrealism

Norman Bryson

Hypermental is an exhibition with an exceptional aim: to explore the visual art of modernity not in terms of schools, styles or media but through the category of subjectivity. There can be no doubt that the modern period has involved an enormous intensification of internal, subjective life. While in the external, social sphere the modern subject has been defined by increasing pressures of discipline, collective organization, rationalization and standardization, in a strangely inverse fashion visual art has followed a different course, going inward and down, in a counter-movement that seeks, in the depths of the subject, disorder, irregularity, the irrational and the transgressive. Across each of its sections, Hypermental gathers images that stand for different aspects of this turn or drive to inwardness, across two historical moments in particular: Surrealism and today. Surrealism occupies a crucial turning point in this historical development. The territory that was opened in the twenties and thirties remains with us today, as part of the 'unfinished' project of modernity.

Eros, c'est la vie: Duchamp's words have lost little of their original charge. From the late nineteenth century on, if it has been believed that the human subject possesses a secret core and an abyss-like interior, in the heart of that abyss and its secret depths lie the sexual drives. The divergence between 'high' and 'popular' art could be described as a simple disagreement over which discourse is best suited to describe that inner core of the subject. While the commercial mainstream has tended to follow the discourse of Eros and romance, based on an affirmative view of sexual love, especially as this is expressed through the social form of the heterosexual couple, the avant-garde has consistently pursued a darker, Sadeian discourse of Thanatos and death-drive, fracture and disintegration.

For Hans Bellmer, as for Georges Bataille, eroticism has everything to do with the convulsions of the subject in extremis, in the throes of a force which so far from binding the subject to a stable position in the world—a social ego—instead pulls the subject toward a passionate shattering, through energies that lead always downward, into abjection, the body in pieces, the body pulled apart by its drives. Bellmer's work still has the power to offend—to insult, by its transgression, the entire set of discourses that would make of love a redemptive force in the world, a union of partners, a meeting of minds. Bellmer's intense objectification and reification of the female body remains radically unacceptable in terms of sexual ethics and social justice. But the premise on which his excruciating imagery is based declares from the start that a component, at least, of sexual energy involves an undeniable, ineradicable negativity. Perhaps Bellmer always gives the viewer two options: viewing the scene from outside, as though there were no connection to one's own nature, and responding with hurt and indignation at the assault on a certain narcissistic image of the human subject that insists on Eros and affirmation. Or the viewer can shift position and enter—however briefly—into the terrain of sado-masochism. Here, the terms are altogether different. A physical sensation that under normal circumstances would involve pain now transmutes alchemically into pleasure. Against the whole economy of reason and social order, sexual energy switches the minus sign to plus. The balance between self-preservation and self-destruction goes into reverse: the subject actively seeks and finds pleasure, perhaps great pleasure, in its own undoing.

Yet Bellmer's bleakness is only one tone that can be attributed to this psychic terrain—consider Louise Bourgeois' Couple (1996). We are in the same fantasmatic region of bodily reification and fragmentation, the reversion from animate to inanimate in the context of amorous passion. But a certain wit and affection reinterprets this primary situation in terms that come close to comedy, or include aspects of humor in a broader, more generous perspective. If Bellmer shares with Freud a tendency to view the downward pull of the erotic in terms of disaster and dread—the end of the human subject as we know it!—Bourgeois' shirt and collar make light of it, as though making heavy weather of such an obvious component of the erotic were typical of the kind of melodrama that boys are always bringing up whenever the phallus is remotely under threat. For the solemn guardians of phallic rule (Bellmer, Freud) the problem of eroticism's downward pull is indeed that the phallus no longer commands the scene: libidinal energy is traveling

everywhere, into multiple bodily sites, into diffusions and diffraction. The unity and stability of a sexual regime focussed on phallic law is profoundly under siege.

Yet from a feminist perspective, this may not be such a bad thing. Louise Bourgeois' Fillette, like her Couple, starts from a different position: suppose that the supremacy of the phallus as ultimate regulator of sexual energy is itself a fiction, not bedrock truth but a fantasy—raised to the level of ideology? In Fillette the phallus is dethroned (terrible shock for the boys!) yet viewed, like her Couple, with a certain affectionate appreciation. With Meret Oppenheim's Couple (1956) desire has migrated away from the phallus to a pair of shoes—but it's not the end of the world.

Cindy Sherman's Untitled, from 1991, may be less sanguine concerning these possibilities. In so far as the death-drive component of sexuality remains structured by gender difference, it can only repeat, in this dark descending register, the terms of masculine domination. Though both the male and the female figure are in the throes of reification and disintegration, the masculine figure remains intact and in control; it is the female body, as in Bellmer, which bears the full burden of disintegration. Yayoi Kusama may share with Sherman a similar ambivalence concerning jouissance. Kusama's Accumulations, objects covered with phallic-shaped protuberances that she has been making since the sixties, like Bourgeois' Fillette, seem at first sight to be a major strike against the phallic regime—the phallus deposed, turned into ornament and decoration, and absorbed into domestic space. Yet the subjectivity associated with this move lies a long way from Bourgeois' sense of wit, amusement, affection. Consciousness here is absorbed by compulsive repetitions, in a kind of hypnosis or trance. It is as though once the phallus—as the master-term of psychosexual order and of regulated subjectivity—no longer governs, the field of consciousness breaks up into atoms, points of energy-desire spread out to a maximum of disaggregation and decenteredness. The points in this field may grow or shrink, advance or recede, but they cannot coalesce into anything like an egoic center: flows of scintillating sparks on which Kusama herself floats, as though on clouds.

Matthew Barney's Cremaster 1 (1995) occupies an unusual position in this series. Sexual difference is still the governing principle, and its location is very much within the phallic

order—the Cremaster muscle being that part of the male anatomy responsible for retracting the testes when the outside temperature changes. Yet Barney's complex visual poetics seems to locate sexual difference less in the male or female human body than in the biosphere itself. The smiling female faces are in a sense not human at all, but personifications or anthropomorphic projections of energies that exist in a larger program of sexual reproduction, somewhere between the protein chains of DNA and the pollination of flowers. Barney's divinities are genuinely like the Greek gods in that they resemble human beings, yet belong to a larger pattern of life, one that includes the human only as a subset. Just as the gods would from time to time appear before mortals in human-seeming form, in Cremaster 1 the queen and her retinue take on the resplendent forms of a Busby Berkeley pageant. Yet this may be no more than a concession they make to human scale and the human imaginary: with them sexual difference is superhuman, on a scale with planetary life. Or is this just the boys again, building themselves up, boasting as usual?

Let us stay with this simple proposition: that the process of social and psychic transformation we call modernity unfolded along two planes or vectors, exterior and interior: a modernization of the environment (industrialization, urbanization, technological intervention) and a series of internal developments that conferred on the modern subject an inwardness of unprecedented profundity and significance. What is the relation between these two separated worlds?

The "Art and Reality" section of Hypermental indicates one of the major ways in which 'outer' and 'inner' were constructed in twentieth-century visual art, through the discourse of cultural resistance, transgression, and utopia. Though for the Surrealists the outer world might be pretty much a lost cause—hopelessly given over to the forces of rationality and social management—the psychic terrain of the unconscious remained untouched, beyond the reach of the authorities. It might take exceptional measures to reach and release the energies gathered there, but when they were, in principle the walls of the city might be shaken.

We can follow the afterlife of this Dionysian discourse right into the sixties. On a number of fronts the function of art is still that of disturbing the peace of reason by erupting, with as much eclat as possible, into the spaces of everyday life.

Niki de Saint Phalle's humungous female body at <u>Hon - en katedral</u> absorbs inside itself the rows of orderly, obedient citizens standing in line and reading the newspapers. Art constitutes one area, at least, that is exempt from the social conditioning that has overtaken the outer world. In the first Happenings of Allan Kaprow a similar carnival atmosphere prevails. The audience, rather stiff in their seats, is exposed to a spirit of misrule: art jumps out of its aesthetic enclosure, overturns the proscenium arch, and jubilantly reinvigorates the repressed, yet delighted audience. Valie Export leads her man on a leash through the chilly streets. In the documentation of the performance you can see craziness lighting up the faces all around. In the distance people appear lost in a more or less oppressive mundanity. Then, as they get nearer to the performance, expressions melt and quicken as though shaken from sleep. Art merging into life, re-animating the world of conditioning and disciplined routine.

This idea of the intrinsic opposition between interior and exterior worlds begins to grow uncertain with the advent of Pop Art. Richard Hamilton's collage <u>Just what is it that makes today's homes so different, so appealing?</u> (1956) portrays the newly arrived economy of postwar affluence. It has never, I think, been clear whether the tone of Hamilton's work is satirical or celebratory, but more important is its insight into the nature of this new economy: that the goods themselves have somehow disappeared inside their own representation, and that the system of representation—mass media—has a central purchase on structures of desire.

The point is the fundamental break that this insight makes with Surrealism. There, the hidden regions of inner life, of desire and the drives, are like an oasis, a reservoir of primal or authentic feeling that can be used <u>against</u> the forces of instrumental reason governing the outer world. Yet what if the new economy is able to generate its cornucopia of goods precisely by its capacity to manipulate desire, channeling and harnessing the drives toward its own ends? The new consumer economy of the fifties and sixties is perceived by the visual arts as a colonization of the unconscious by industrial force. In order to penetrate the interior of the subject, material goods must first be recomposed in the language that the unconscious recognizes and understands, as Image. Until that moment of transformation they remain mere things, objects of the outer world, heavy and opaque. But as Image such commodities become subtle and mobile; they

can travel into the subject's interior domain and organize and transcode the drives so that the latter merge into the image-object, infusing it with libidinal energy.

James Rosenquist spells it out: <u>I Love You With My Ford</u> (1961). The upper area of the canvas shows the heavy industrial object as it enters, subtilized into Image, into the psychic interior. Below, the still inchoate reservoir of the drives, as these emerge within the body and the unconscious toward the field of conscious awareness. Between them, the image of desire: desire in its official form, as the couple, the kiss. Rosenquist's analysis is remarkably close to Hamilton's: from goods to Image, and from Image to desire. The genius of the consumer economy lies in its power to inject the commodity form deep into the interior of the subject by letting the commodity 'ride', as Image, on the structures of sexual difference that articulate unconscious desire. Richard Prince's <u>Untitled (Cowboy)</u> and Barbara Kruger's <u>Untitled</u> ("I shop therefore I am"), both from 1987, portray the same psycho-industrial economy a generation later, when a new form of feminism has emerged that is able to describe in critical terms precisely this colonization of subjectivity. The prevailing sexual and economic orders are powerful and insidious exactly because of their purchase or hold on the structures of sexual difference out of which subjects are built.

Perhaps the most chilling index of the loss of the old, Surrealist faith in the unconscious as a bedrock of authenticity opposed to the falsities of the outer world is the disappearance, in both Prince and Kruger, of the artist as an originating creative subject. Art itself is no longer exempted from the general process of internal colonization. With Prince, the line between advertisement and work of art disappears; with Kruger, the forms and rhetoric mime the layout of mass magazines. Though the tone of both works is sardonic, it is the kind of satire in which no clear line of demarcation can be drawn between the satirist and the object of his or her attack. Exactly because the economic and sexual orders now operate from deep within the subjective domain, there is no easy way out of the trap, no high moral ground or vantage point from which to look <u>down</u> on this process.

Jeff Koons pushes this one degree further. <u>Pink Bow</u> (1995-97) describes the lure or allure of the commodity as a kind of shine or glitter that is both soft (desirable) and hard (industrially produced). The work's satirical intent is clear

enough: it hardly matters what the goods actually are—what counts is the magical appearance that the goods seem to possess as their glamour works its seductive power on subjectivity. And yet that visual glamour belongs to the painting itself, in its brilliant simulation of bright reflective surfaces. It is a painting with extraordinary passages and transitions; it, too, seduces the viewer with its brittle play of light. Between painting and commodity, then, there is no essential difference. The commodity form has absorbed and colonized subjective space. From what position, then, does the painting's critique of the colonization of desire emanate—if indeed it does? Or is the painting embracing the commodity form without irony or reservation? Is painting collapsing into commodity, kissing commodity, as in Rosenquist where the drives merge with an automobile in that central kiss?

By including Surrealist alongside contemporary work, Hypermental highlights the way that much in the present climate is a continuation of Surrealism's pursuit of the unconscious by quite other means. Consider, for instance, abstraction. Surrealist strategies present the depths of subjectivity primarily through a language of interruption and montage, based on figuration (Dalí's Portrait of My Dead Brother, 1963). The real world is shown as broken or driven by an eruptive unconscious. But the 'optical' turn in painters like Yayoi Kusama, Fred Tomaselli and Karen Davie locates the image not on the cusp between the unconscious and consciousness but deeper down, in the kind of hypnotic imagery that precedes the figurations of the dream-work. Here the mind contemplates no particular object; lacking an object, subjectivity becomes limitless.

Kusama's patterning of the canvas brilliantly conveys this floating, infinite zone within subjectivity (as in her Infinity Net Paintings). The whole field pulsates in unbounded space; the energized patterns expand and contract, advance and recede, accelerate and slow down, as though what the image portrays is a stream of psychic energy not yet organized by the principle of ego or center. Yet this is not quite nirvana: there is an edge and unease within this deepest layer of the psychic interior, a feeling of engulfment, as though the stream of psychic energy carried a negative charge. A similar quality prevails in Tomaselli's Bug Blast (1997). We are in the same hypnotic space, deep inside the mind, and the energy there is vast and powerful. But it also impacts harshly, with a sense of destruction and death-drive

intertwined with creation and life force. Karen Davie's Wanted (1998) is much more even, with smooth sine curves, highly dynamic, but less threatening. Strangely enough, abstraction seems in such work to fulfill one of the highest, Kantian aims of aesthetic practice: to present to each of us what we have in common, patterns of consciousness and feeling from a shared core of subjectivity that is deeper than the world of ego and social separation.

In Hypermental's section on the Neurotic Gaze, Surrealism's method of making the unconscious cut across the field of normalized reality becomes a method of fusion. Anna Gaskell's and Olaf Breuning's photographs give to scenes of youthful sweetness a lining of dread. Within everyday, banal reality lurks demons: Damien Loeb's Klan wizards floating down the highway and the panic that bursts out in a simple coastal motel; or, Jeff Wall's gargantuan librarian. If in Surrealism the energies of the unconscious interrupt and eclipse the normal world, here those energies are secreted deep within the real, like a corrosive atmosphere.

Hypermental shows that modern art's exploration of the depths of subjectivity is far from over. Given the power and momentum of such a project, who knows what the next century of work may reveal?

GRISELDA POLLOCK

PSYCHIC ALCHEMY: SEXUAL OBJECTS AND FANTASMATIC BODIES

In 1992, ten years after her belated entry into the canon of Euro-American art, Louise Bourgeois made an environmental work for documenta IX titled *Precious Liquids,* subsequently acquired by the Musée Nationale d'Art Moderne in Paris and shown, together with the huge mechanised piston, *Twosome* (1991) at the enormous exhibition about sex, the body and desire in art: "Féminin/Masculin" at the Centre Pompidou, Paris, 1996. From the outside, *Precious Liquids* is a large wooden water-tower like a giant barrel, girt about by an iron band upon which are pressed the words *Art is the Guarantee of Sanity.*[1] Entering the opened door rather like the miniaturised Alice making her way into

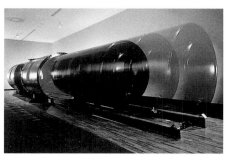

LOUISE BOURGEOIS TWOSOME,1991
Steel, paint and electric light,
80 x 456 x 80" / 203.2 x 1158.2 x 203.2 cm
Foto: Peter Bellamy

Wonderland's magic garden, we are in an tall interior comprising a child's bed surrounded by a tree of glass phials containing bodily fluids associated with all functions and all emotions, while hanging to one side is an oversized coat within which nestles a child's dress embroidered with the words *Mercy* and *Merci.* Louise Bourgeois has made many statements in her typically direct and unembarrassed way about this piece.

> Since the old fears were linked to bodily functions, they resurface via [the body]. For me, sculpture is the body. My body is my sculpture. Glass becomes a metaphor for muscles. It represents the subtlety of emotions, the organic yet unstable nature of the mechanism. When the body's muscles relax and untense, a liquid is produced. Intense emotions become a material liquid, a precious liquor.[2]

This is a complex statement shifting between the artistic modes of representing bodily processes and the psychic connotations of both physical functions and the aesthetic effects of objects that metaphorically invoke the psycho-somatic. The material object is both a vicarious and non-mimetic figuration of a body's memory of feelings and a metaphor for the embodied but sensate subject experiencing the world of emotion through a psychically invested physicality.

At other times, the artist has provided a dream-like interpretation in which the large coat sheltering the girl's dress stands both for the excessively phallic father, "the Great Extravagant Show Off,"and for the unconscious itself: "The little girl takes refuge in the same way artists do."[3] Unconscious mental space, equated with the spaces art invents for itself, becomes a kind of habitation, a second mother. This suggests repetition, but repetition with the displacement that the artist may be *like* the little girl, but she is not a little girl, for, according to Louise Bourgeois' account of the work of psychological metamorphosis commemorated and imaged by the piece itself, the little girl's action of

gaining psychological insight is part of a process of maturation: the little girl, evoked by the bed and dress, finally "discovers passion, rather than terror."[4] The piece signifies the changing meaning or affect attached to the bodily site of psychological experience. The body is medium, whose meanings are, however, produced in affective experience by the psychological subject-in-process/-on-trial, through time, in the relay between adult and memory. The installation is hence retrospective: made from the point of an adult woman- subject who knows passion, but remembers childhood terror before eroticisation. It is also an externalisation of an inner, mental space in a perpetual intermediate time zone between past (childish terror) and future (adult sexuality), between past (childhood) and present (artistic practice). It is thus akin to the dream, that hovers up residues of daily life and allows them to become the carriers or screens of ancient memories still aching shapelessly in the subject's emotional and psychic being.

This multi-dimensional, stratified, composite sense of subjectivity is deeply psychoanalytical. The human subject is the effect of both memories and anamnesis, remembered situations, and repressed associations, terrors or pleasures that sometimes can hardly be faced. Artistic practices that continue to mine the still rich possibilities of what first emerged as the surrealist impulse (different from the historically and ideologically situated artistic project Surrealism), but turning it through a *feminine artistic subjectivity*, create aesthetic spaces populated with signifying objects that can catch both the memory-bearing situation and provoke the repressed affects of formative moments only knowable through the retrospective work of artistic or other kinds of self-critical re-interpretation. The art work as echo of childhood memory is thus the paradox of an originary repetition.[5]

The outside of Louise Bourgeois' *Precious Liquids* invokes another major modernist machine about sex and desire: Duchamp's last, enigmatic installation peep show: *Etant Donnés,* 1947-1966 (Philadelphia Museum of Art). Excluded by ancient wooden doors set flush with the wall, the viewer must peer between the wooden planks to catch a glimpse of an artificial glade on which lies exposed a cast of a drawing of a sprawling female body. On the other hand, in the interior of *Precious Liquids,* which invites us into a space that signifies both the inner workings of a body and of a mental space, the juxtaposition of signs of the perversity and difficulty of desire signified through a mechanistic evocation of the body through its fluids, necessarily evoked Duchamp's *The Large Glass* as the single most telling meditation on the impossibility of gratified desire in the canonical field of modern art. Rosalind Krauss has suggested this affinity between Louise Bourgeois and Marcel Duchamp's "bachelor machine."[6] Marie-Laure Bernadac argues, however, that *Precious Liquids* "could thus be seen as an inverse, feminine pendant to Duchamp's *Large Glass,* in which the relation between the bachelors and the bride is mirrored by that between the girl and her father (or fathers)."[7] The transparency of Duchamp's glass is countered by the dim interiority of Bourgeois' drum/barrel/room, and the "dry sterility of the bachelors' is undone by the "moist fecundity of maternity" of the leaky puddle on the bed, suggesting amniotic fluid of a birth, or a [n artistic] renaissance."[8]

LOUISE BOURGEOIS PRECIOUS LIQUIDS, 1992
Wood, metal, glass, alabaster, cloth, water,
167 x 175" / 425 x 445 cm
Collection Musée d'Art Moderne Centre Georges Pompidou
Photo: Rafael Lobato

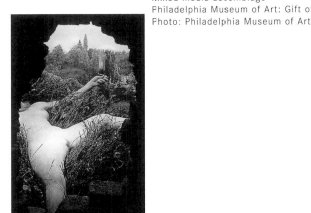

MARCEL DUCHAMP ETANT DONNES:
1° LA CHUTE D'EAU. 2° LE GAZ D'ÉCLAIRAGE... 1946-66
Mixed media assemblage
Philadelphia Museum of Art: Gift of the Cassandra Capital Foundation
Photo: Philadelphia Museum of Art

Louise Bourgeois's work plays in the intellectual ball park of that unfinished business, signified by Duchamp's major works, of representation and sexual desire through the invocation not of an anatomical body but a corporality figured through mechanism and phial, emanation and liquid, that displaces all existing visual traditions and poetic tropes for the representation of the body and desire by borrowing, from incongruous sites of mechanical modernity, another set of signifying elements and processes that stress a conceptual, symbolic and non-naturalistic understanding of desire. Frustrated desire in Duchamp's case and "the transformation of girlish terror in the face of sexuality and the body into passion" becomes a matter of both hysterical conversion and dream-like displacement through a psychic alchemy. Bernadac's interpretation of a particular work as a feminine inversion, however, undoes the Duchampian gesture, and gives Bourgeois' work a specific content, which, paradoxically, reconfirms the phallocentrism of the bachelor machine: masculine = phallic / feminine = maternal.

In her analysis of the metaphors of the bachelor machine in film studies, Constance Penley, quoting Michel de Certeau, insists that the bachelor machine cannot "write the woman" and that dream images of machinery stand for male genitals (Freud). If feminists try to disturb these tendencies by deriving a counter theory from the feminine body as the basis for a different system of drives and subjectivity, following Kristeva's theory of the semiotic or Luce Irigaray's theory of the multiplied sites of sexuality on the feminine body, for instance, there is a danger of collapsing desire, subjectivity, sexual difference back onto a concrete corporeal identity in which the only way to think feminine difference is through the specificity of the maternal body: (already symptomatic in Bernadac's confusion of some physical evocation of birth and a psychological self-re-invention on the part of the artist, Louise Bourgeois). Constance Penley wants to insist upon the fundamental legacy of psychoanalysis for feminism twisting between phallocentrism and the dangers of essentialism that reconfirm it. "Clearly what we need to counter the 'maleness' of the cinematic apparatus (or modern art) and its theories is not to introduce the *feminine body* into those theories but to insist upon a way of theorizing cinema (or art) that does not eliminate the question of *sexual difference*."[9] Sexual difference is thus posed, through psychoanalytic theories of fantasy, as an effect without a predetermined anatomical cause. Sexuality does not follow from what is given by the body's morphology but is introduced into the infant becoming a psychological subject as *fantasy*, as a mental image. "The formulation of fantasy, which provides an exhaustive and complex account of the *staging and imaging of the subject and its desire* is a model that very closely approximates the primary aims of the apparatus theory."[10]

Louise Bourgeois moved beyond Duchamp's invocation of the cinematic frame within "painting" (the divided transparent panels of the *Large Glass* might be read as two frames of a film strip) by turning to sculptural installation, to orchestrating objects, and to choreographing the viewing subjects in common space. But within that field, she has deployed the Duchampian gesture to create a new

essary fantasization of this exchange of bodily fluids generates intensely experienced pleasure through linking the act to the trajectories of desire. Stripped of both, the burden of the "icon" shifts to the viewer's encounter with the way the sculpture's metonymy produces not a thing, but a sight: a snatched, half-comprehended glimpse, a memory of a shock, a kind of primal scene in which the "unnatural" sight of adults lying down, a man atop a woman, his clothed torso, her nakedness, provide information but not knowledge. Strung between the passion that motivates adults to such actions, and the sense of terror caused by a child's premature encounter with the sight of sexuality, the piece denaturalises both. In some exhibitions, the viewer encounters this object without a vitrine, like unexpectedly finding bodies grappling on a bench, and the shock of such an encounter allows sex to enter representation as an effect of its subjects.

As far removed as possible from the misguided notion that to depict genitals, or the sexual act is to get anywhere near a representation of sexuality, or its affective reality, Meret Oppenheim and Louise Bourgeois have both in their diverse ways distilled a syntax with things we use, to stage desire and its subjectivities in a place of viewing objects that are set in a hypermental space.

1) The words are used in *Cell I*, 1991, in conjunction with the phrase *Pain is the Ransom of Formalism*. My longer analysis of this work appears in a special issue of *Oxford Art Journal* devoted to the work of Louise Bourgeois, "Old Bones and Cocktail Dresses: Louise Bourgeois and the Question of Age" *Oxford Art Journal*, Vol. 22, no. 2, 1999, 71-100. See also Alex Potts, "Louise Bourgeois: Sculptural Confrontations," ibid, 37-54, for a discussion of the phrases used in *Precious Liquids*.

2) Note by Louise Bourgeois, 5 November 1992, to Musée Nationale d'Art Moderne, Paris, after its acquisition of *Precious Liquids*.

3) Ibid.

4) Ibid.

5) Sarah Kofman, *The Childhood of Art: Freud's Aesthetics*, New York; Columbia University Press, 1992, 187-189

6) Rosalind Krauss, "Portrait de l'Artiste en Fillette," *Louise Bourgeois*, Lyon, 1989.

7) Marie-Laure Bernadac, op. cit., 137

8) Ibid.

9) Constance Penley, "Feminism, Film Theory and the Bachelor Machines," *The Future of an Illusion: Film, Feminism and Psychoanalysis*, Minneapolis: University of Minnesota Press, 1989,79.

10) Ibid, 79-80. Penley's emphasis.

11) This is the key phrase I elaborate in *Differencing the Canon: Feminist Desire and the Writing of Art's Histories*, London: Routledge, 1999.

12) Meret Oppenheim, *Aufzeichnungen 1928–1985*, edited by Christiane Meyer-Thoss (Bern/Berlin: Gachnang & Springer, 1986), p. 45, translated by Catherine Schelbert.

13) For a useful analysis of clothing in surrealist photography and the difference of the photographic perspective on reading the image, see Bryony Fer, "The Hat, the Hoax and the Body," in *The Body Imaged*, ed. K. Adler and M. Pointon, Cambridge: Cambridge University Press, 1993. For a useful study of the legacy of Surrealist object, hysteria and the feminine, see Margaret Iverson, "Visualising the Unconscious: Mary Kelly's Installations," in Margaret Iverson, et al., *Mary Kelly*, London: Phaidon Books, 1997.

THE FUNDAMENTAL PROCESS IN MODERNITY IS THE CONQUERING OF THE WORLD AS AN IMAGE. THE WORD "IMAGE" NOW MEANS: THE FORMATIVE IMAGE FOR PRODUCTION ACCORDING TO AN IMAGINED REPRESENTATION. Martin Heidegger, Die Zeit des Weltbildes, (Age of the World-Image) in: Holzwege, 1950

I NEVER SEE SUCH A LIAR AS THAT MAP.
Mark Twain, Tom Sawyer Abroad, 1894

"THE REALITY OF TIME HAS BEEN REPLACED BY ADVERTISING FOR TIME."
Guy Debord, Society of the Spectacle, 1967

REALITY DIFFUSION
NEW EXPERIENCES OF REALITY IN ART BETWEEN THE HYPERREAL AND THE HYPERMEDIAL

PETER WEIBEL

As a consequence of the industrial revolution, machines and media as new interfaces between humans and reality have radically changed the human relationship to reality, that is, the human experience of reality. The industrial, machine-based revolution and the post-industrial, information-based revolution have changed the face of the world to such an extent that many people no longer recognize it and therefore proclaim that the world is vanishing. In truth, only the familiar world is disappearing and the degree of vanishing is only a measure for the degree of changes to the world. The world itself is not disappearing, but only its historical form of appearance. The historical order of things is dissolving and therefore the contours of the new horizon of things are described from the perspective of this vanishing, that is, in the rhetoric of negation. In the panorama of vanishing we describe the world as a place of

alienation, of devastation and of absence. That everything is disappearing has been claimed since Cézanne's famous dictum, and thus the world becomes a place of absence, a non-place. But precisely this non-place is literally utopia. The rhetoric of the emergence of the new is inscribed as negative in the rhetoric of disappearance. The lamentation about vanishing is thus basically a conjuring of utopia. In disappearing, utopia's outlines appear. Those categories which, under the pressure of the post-industrial revolution, have been transformed so much that they have apparently disappeared include space, time, the body, and the real.

The deepest transformation was the substitution of a body-centered experience of space and time by a machine-centered and media-centered experience of space and time. Since the invention of telegraphy

around 1840, it has become possible to send a message without a messenger, a message without a physical medium, a message without a body. Before that, each message required a body to overcome space and time: from soldiers to pigeons, from ships to horses. With telegraphy, the message and the messenger, sign and body were separated from each other. Signs were transmitted from one place to another distant place without a body. Since we have been passing through space by railroad, by car and by airplane, we experience space and time with a speed which lies beyond the natural limits of our organism and our organs. The experience of space and time through machines and telemedia such as telegraphy, telephone, and television breaks through the limits of our body's reach; it is thus trans-anthropomorphic and goes far beyond the body's experience of reality. Clearly, this

does not mean an eradication of the body, but rather its technical extension. Machines and telemedia work like technical prostheses which extend the body into space and time, so that ultimately the real body can be doubled by a virtual body. The separation of messenger (body) and message (code) is the principal axiom for the new reality. The ties between new machines and media on one hand and the human body on the other are being loosened.

The separation of the messenger's body from the message's code is the basic experience which defines our new conception of reality. Since messages started to go on journeys without messengers by being transmitted in code as electromagnetic waves, the old world has collapsed. The machine-centered and media-centered experience of reality has stepped into the place of the body-centered experience of reality and exceeds the human measure, the measuring of space and time by the measure of the human body. It is well-known that the speed of traveling signs has annulled our historical ideas about space and time. As early as 1843, Heinrich Heine wrote: "Space will be killed by the railroad." Those who insisted on historical experiences described the radical transformation in experiencing time and space as a process of disappearance and "devastation" (Hegel), or as alienation. Viewers who are not in a position to detect the emergence of new ideas of space and time, of body and reality, that is, the emergence of positive utopias in this disappearance of the historical world, and who want to restore the historical conditions of the experience of space and time through the

body can therefore rightly be called conservative. Such viewers will, of course, define the transformation of the experience of reality in industrial and post-industrial society as a loss of reality.

Extraordinarily clear and far-reaching symptoms of this change in our experience of reality are found in the art of the twentieth century. Both conservative and progressive tendencies can be detected in these artistic reactions. It could even be said that the majority of artists responded in a reactionary way, that is, that they made efforts to restore the historical or original experience of space and time. The development of abstract art, however, is the greatest achievement of art in the first half of the twentieth century and a clear signal for the withdrawal of art from historical reality. The rejection of the mimetic, representative function, which lies in the nature of abstract art, can be interpreted as the expression of the disappearance of the real, of space, of time and the body, and simultaneously as a utopia. In any case, the withdrawal of painting into its own world of painterly materials means a refusal to continue representing reality in the way we are used to seeing it. Thus, in the second half of the twentieth century, abstract art opened the way for new experiences of reality by proposing a new equation between art and reality. The real penetrates art in the form of everyday objects and also in the form of the real body. Likewise, the spiritual, mental, psychic, and mystical dimension is overemphasized and overexposed. The arts erect utopias of ubiquity and simultaneity, utopias of doubling and simulation. Reality appears either distorted or hyperreal, either insane

or far removed, either constructible or fateful. The changed experience of reality thus becomes the crucial aspect of art in the second half of the century. And at the center of this experience is the primacy of the image over being, the primacy of the medial over the immediate experience of reality. As mentioned, this new experience of reality via art is based on the refusal of the classic function of representation, that is, of the road-map function of art, as we could describe its task of representing physical, social and psychic reality. The loss of the map is introduced like an initial theorem to substitute the body-centered experience of space by a machine-centered and media-centered experience of space. At a very early stage, therefore, art described the transformation of the experience of reality in terms of the divergence of the map from reality, of representation from reality, of the image from being.

In the third chapter of Tom Sawyer Abroad entitled "Tom Explains," Mark Twain describes the experience of crossing the country in a hot-air balloon. Huck makes a remarkable discovery while floating across the countryside: he realizes that the data of perception do not coincide with his map and therefore says to Tom Sawyer,

– "[...] The professor lied."
– "Why?"
– "Because if we was going so fast we ought to be past Illinois, oughtn't we?"
– "Certainly."
– "Well, we ain't."
– "What's the reason we ain't?"
– "I know by the color. We're right over Illinois yet. And you can see for yourself that

Indiana ain't in sight."

– "I wonder what's the matter with you, Huck. You know by the color?"

– "Yes, of course I do."

– "What's the color got to do with it?"

– "It's got everything to do with it. Illinois is green, Indiana is pink. You show me any pink down here, if you can. No, sir; it's green."

– "Indiana pink? Why, what a lie!"

– "It ain't no lie; I've seen it on the map, and it's pink."

You never see a person so aggravated and disgusted. He says:

– "Well, if I was such a numbskull as you, Huck Finn, I would jump over. Seen it on the map! Huck Finn, did you reckon the States was the same color out-of-doors as they are on the map?"

– "Tom Sawyer, what's a map for? Ain't it to learn you facts?"

– "Of course."

– "Well, then, how's it going to do that if it tells lies? That's what I want to know."

– "Shucks, you muggins! It don't tell lies."

– "It don't, don't it?"

– "No, it don't."

– "All right, then; if it don't, there ain't no two States the same color. You git around that if you can, Tom Sawyer."

He see I had him, and Jim see it too; and I tell you, I felt pretty good, for Tom Sawyer was always a hard person to git ahead of. [...]

But Tom he was huffy, and said me and Jim was a couple of ignorant blatherskites, and then he says:

– "Suppose there's a brown calf and a big brown dog, and an artist is making a picture of them. What is the main thing that that artist has got to do? He has got to paint them so you can tell them apart the

minute you look at them, hain't he? Of course. Well, then, do you want him to go and paint both of them brown? Certainly you don't. He paints one of them blue, and then you can't make no mistake. It's just the same with the maps. That's why they make every State a different color; it ain't to deceive you, it's to keep you from deceiving yourself."

Huck Finn believes that maps report facts; he believes in their representational accuracy, just as one believes in the representational accuracy of photographs. If a map shows the state of Illinois in green and the state of Indiana in pink, Indiana has to be pink in reality too. Tom, on the other hand, refers to an immediate painterly problem. The chromatic properties are properties of the map and not of reality. They serve to prevent delusion. But in fact, the opposite is the case, as the example of Huck Finn shows. In the sixth chapter of the same book, "It's a Caravan," Mark Twain comes back to the same problem. Huck Finn believes that he should be able to see the meridians on the earth as they are represented on the map. Because he doesn't see the meridians on the land, he again accuses maps of lying.

– "Oh, shucks, Huck Finn, I never see such a lunkhead as you. Did you s'pose there's meridians of longitude on the Earth?"

– "Tom Sawyer, they're set down on the map, and you know it perfectly well, and here they are, and you can see for yourself."

– "Of course they're on the map, but that's nothing; there ain't any on the ground."

– "Tom, do you know that to be so?"

– "Certainly I do."

– "Well, then, that map's a liar again. I never see such a liar as that map."

The relationship of representation and reality was thus a subject discussed early on in terms of the representational accuracy between maps and the land. Abstraction was the refusal of this representational accuracy (Franz Marc's blue horses) and finally of the function of representation as a whole (Kandinsky). This loss of the representation of reality may be interpreted as a loss of reality. Anyone who does this, however, is in the same situation as Huck Finn. He transfers properties of the map to the land and, because he doesn't find them there, he is disappointed and accuses painting of lying (cf. Sigmar Polke's The Three Lies of Painting, 1994). What abstract painting expresses in reality is precisely and literally that process of abstraction to which the world was exposed in its transformation by the industrial and post-industrial revolutions. In a rhetoric of the disappearance of things, this process of abstraction may be articulated as the transformation of things into commodities or as the emergence of self-referential systems from which new properties and things arise. Hyperreality and hypermentality are reactions to this process of abstraction from the real as set in motion by the change from the body-centered experience of reality to the machine-centered and media-centered experience of reality. In his theory of simulation and hyperreality, Jean Baudrillard also draws on the map/land metaphor to demonstrate the abstraction of the modern world. In Das Kapital (1867), Marx traced the "devastation" (Hegel) of the world through the alienation of human beings from their own products in the

process of transforming the earth back to its economic base. Marx describes the disappearance of things through their transformation into commodities. The world of things appears as a ghostly realm of dead things since they now only continue to circulate in our world as commodities and since their commodity value has come to constitute their proper character as things. Things lose their sensuous, divine or human character when they lose their use-value. It is solely the exchange-value of the commodity that counts in the world of capital. All things have been turned into commodities and all commodities have only one measure, namely, their exchange-value as defined by money. The commodity form of things has transformed objects into specters and inaugurated a great memento mori. The transience of the world was recognized in the transience of commodity values. The disappearance of things through their transformation into commodities was the first great move that ushered in the disappearance of the historical world. "It is no longer table or house or yarn or any other useful thing. All its sensuous properties have been extinguished. Along with the useful character of the products of labor, the useful character of the labor represented in them disappears, and thus also the concrete forms of this labor," wrote Marx in Das Kapital.

The rhetoric of disappearance has consolidated itself in the disappearance of things through the process of the abstraction of commodity values. This is where Baudrillard starts with his idea of universal simulation which wipes out the difference between sensuously experiencable and examinable reality, on one hand, and medially constructible

hyperreality, on the other. When the difference between landscape and map vanishes and people no longer know whether they are standing in the desert or in a map of the desert, the land, of course, also disappears and reality as a whole degenerates into an agony in which simulation can triumph absolutely. In his works, Baudrillard demonstrates that the law of commodity value has extended to the level of signs. This structural revolution is in principle based on showing how the Marxian splitting of commodities into use-value and exchange-value was repeated fifty years later by the Saussurian split of the sign into signifier and signified. The exchange of linguistic signs in the circulation of meaning follows the exchange of commodities in the circuit of money-capital. Saussure himself already related the nature of the sign to exchange, to the general law of value, and to money. Baudrillard couples the doubled structure of the commodity as use-value and exchange-value with the doubled structure of the sign as signified (representation, image, idea) and signifier (material appearance). The exchangeability of all commodities corresponds to the function of the sign as symbol: the exchangeability of all signs. As a symbolic exchange-value, the sign may be exchanged not only for any other sign, but also for any other commodity, where the use-value corresponds to the signified and the exchange-value to the signifier. The abstracted universal exchangeability of commodities and their freely floating values therefore correspond to the 'freely floating signifiers' which generate the semiocratic catastrophe and confusion in media society.

In "La précession des simulacres," Jean Baudrillard refers to the story by Jorge Louis

Borges about the map and the land in order to demonstrate his thesis that simulation precedes reality:

In that Empire, the craft of Cartography attained such Perfection that the Map of a Single province occupied the space of a city, and the Map of the Empire itself an entire Province. In the course of Time, these Extensive maps were found somehow wanting, and so the College of Cartographers evolved a map of the Empire that was the same Scale as the Empire and that coincided with it point for point. Less attentive to the Study of Cartography, succeeding Generations came to judge a map of such Magnitude cumbersome, and, not without Irreverence, they abandoned it to the Rigours of sun and Rain. In the western Deserts, tattered Fragments of the Map are still to be found, Sheltering an occasional Beast or beggar; in the whole Nation, no other relic is left of the Discipline of Geography.

Thus, since Borges and Baudrillard, we know that maps have the tendency to devour the land. Those standing on a map which has the same dimensions as the land no longer know whether they are standing on land or on the map. The media apparently simulate reality so perfectly that it has become impossible to distinguish between reality (land) and representation (map). In this model, however, there is still the hidden assumption of an originary difference, an ultimate kernel of ontology, because not recognizing or being able to observe the difference presupposes the existence of a difference. The metaphor of the relationship between map and land is thus an observer's

problem. The observer is subject to non-difference or the inability to differentiate. An alternative possibility would be to construct the distinction between map and land oneself, but this option has scarcely been explored. On the contrary, almost all media theories still entail a kernel of ontology by postulating the precedence of reality over simulation. The classical European antinomy between being and illusion has found a new playground in its medial interpretation.

The question posed by the German sociologist, Oskar Negt, namely, whether there is a "reality underlying the public sphere mediated by the media," thus reminds one of the old metaphor of map and land, where the land is covered by the map. Negt assumes that there is a reality of the land but that it is only covered by the map of the media. If the media were removed, the underlying reality would appear. His model thus confirms classical ontology which makes do without an observer position. The difference between illusion and being, between media and reality, is an ontological category.

Only through the insight that the distinction depends on the observer does one realize that no ontology is necessary, but rather that the relationship of media and reality is a question of cartography. The cartographer as observer can construct the difference. The emergence of the global media industry does not show that the map is devouring the land, but on the contrary, that global media conglomerates construct the land with the aid of the media.

The events since 1989, which can be regarded as signs for the downfall of communist drafts of society and for the rise of neo-liberalism in collaboration with global media conglomerates and transnational corporations, provide evidence for the thesis that the map itself not only maps the land but also constructs it. The map does not tend to devour the land (in which case we would still know what the land is or once was), but rather tends to create it. The media construct reality. As early as 1962, Jürgen Habermas diagnosed this "structural change in the public sphere." It is the degeneration of bourgeois public life which Richard Sennet described in The Fall of Public Man. The question crystallized ever more clearly in the second half of the twentieth century in view of the now self-evident construction of reality by the media: Is there anything beyond the media? The globalization of the media leads to a reality diffusion in which any communication, whether true or false, and any observation, whether true or false, has consequences in reality.

Literature

Jean Baudrillard, "La précession des simulacres" in: Traverses No. 10, Paris, 1978

Jorge Luis Borges, A Universal History of Infamy, London, 1975

Jürgen Habermas, Strukturwandel der Öffentlichkeit, Neuwied 1962

Oskar Negt, Warum SPD? 7 Argumente für einen nachhaltigen Macht- und Politikwechsel, Göttingen, Steidl Verlag, 1998

Richard Sennett, The Fall of Public Man, New York, 1977

Mark Twain, Tom Sawyer Abroad (1894), Berkeley, 1982

Notes Made after the Fact Sibylle Berg

Question: What was the most terrible moment in your life?

(after hanging Damien Loeb)

Reality A: It was almost autumn. The morning already thick with fog and smells putting me in a state that might almost have been mourning because I didn't know how to respond to the onslaught inside me. We had gone to the country. We had fled to a house, very beautiful, for rent, because we had been in love for three months and we knew that love falls apart in the city, and we didn't want it to. The picture was hanging in the bedroom.

And Anna. The way she ran in front of me, the way she laughed and her face wet from the water in the lake. Her hair on my stomach and it would never end. Whole at last. It was like home, like the house in the country, like that. When we heard about the war, we thought it was a joke. I mean we never believed that it might come true. Listen man, a war. Here. Nowadays, I mean, it's inconceivable. And when they reported it on television and showed pictures, we still didn't believe it. We saw people who might be dead, but dead people are only on television and in the papers. We were afraid but we acted as if they didn't exist, as if there was no war.

Simply acted as if there was only us and the country and autumn. I loved waking up with her in the morning and knowing that the tree in front of the window was ours and that we didn't have to go anywhere. And maybe it would go on like that forever, I thought. And I looked at the ceiling. The sun was there, in stripes, and Anna's head resting on my shoulder.

Then the door of the bedroom was kicked open. The door was kicked open and soldiers were standing in the room. That moment lasted forever. I was everything at once. Frozen, very cold, and I felt sick, and my mind went blank when I looked at the men, there were three of them. And it was not a movie, you can tell right away when it's real. The men smelled and it made me feel sick. One of them held a gun to my head. I was frozen. I thought, this can't be what it is, surely it can't be, it's today after all and war, I mean, war is not possible, a mistake. And slowly looked at Anna. She was naked and one of the soldiers was in her. Then the other one. It was so quiet, I only heard how the one who'd just had her slit open her stomach while he was still in her, so in the silence I only heard her intestines coming out. A damp sound. Then the first soldier put the gun in her face and pulled the trigger. The shot sounded muted too. I couldn't understand, I really couldn't. I lay next to her. The soldiers left. Softly. I stayed behind.

Those were the seconds that nothing can follow.

Reality C: And it was the first evening in my own apartment. It was empty, the apartment, and totally groovy. There was a bed, this picture and my hi-fi, the rest smelled of fresh paint. I thought I could do whatever I wanted, I thought the worst part of my life was behind me and that I would now only be happy since now I only had myself to listen to. It was like being locked inside a department store and being able to name what you want.

I had left home and moved to a city that I admired because it was a city of opportunity. Spring, and I was sitting on a windowsill. Swallows were flying high and twittering. The air was very soft and the light absurdly yellow. Just at the moment when the silence had become too much and could easily have turned into sadness, my friend came by with a girl. The girl, well it was like she was from another planet or something, what I mean to say is I'd never seen anyone like that before. Something flowed out of her that made me feel warm, really warm. I thought: I want to look at that girl forever. Never again do anything except look at her day and night. Later we were sitting in the car, I don't remember what make, and I put a tape in the deck. It was a mix of my favorite songs. We drove for hours through the evening and I didn't have to worry about them not liking my music. It was like being in a hot-air balloon, if you know what I mean. Every time we took a bend, the girl, I don't know to this day what her name was, brushed against me. And moved a little closer. The sky was red and the music warm and it was a moment of infinity. Just when I could barely breathe anymore, so scared that the moment would end because of that. I ended it. Because I knew that there would never be such a perfect moment again. Only the wearisome search for this feeling, in vain. Then curtain.

Question: What was the happiest moment in your life?

(after hanging Mariko Mori)

Question: What was the loneliest moment in your life?

(after hanging Anna Gaskell)

Reality B: The alternatives that I saw were limited. I could have killed myself. Like so many other people, I was too much of a coward, because for example I thought of decapitation. Because you live a few seconds longer and then I might not have wanted to die anymore. That must be ghastly. The other possibility was to run away. Out of life. I'd been sitting on a chair for a few days, the child was lying in bed, it was dead. Not that I would have done anything about it. I just hadn't looked after the child anymore because I didn't want to begin loving it. I mean I knew that my life was messed up with the child. I knew it the minute it was there, what a stupid mistake. And I thought if I ignore it, I'd be able to go on living my life like before. Now it was lying there dead and that bothered me too. Because I realized that the child would've been my only chance. I felt so sorry for us when I saw it lying there so white and small. The picture that had been given to me and that I'd never liked was hanging over its bed and then I was sitting next to the child, like I never did when it was still alive.

I took off. Walked until the city was behind me, simply didn't stop walking, that keeps you going somehow. The area was uncommonly ugly. Factories, wasteland, and so on, the ground frozen, the leaves in it brown and sort of rotted. And then I thought of the child again when I saw the leaves. There was no one who had liked me. Copulating: yes, lots; liked: no. Cut and dried. I was the loneliest person I knew, I didn't even like keeping my own company, and the child might have been a way out but I hadn't realized it. That it might have been someone who likes me. All I had thought was that it would get in the way of my hunting for happiness. Happiness, and then I laughed but it turned into a cough. I staggered and could barely keep my balance, but good to be emptied and thought only about staying on my feet. Then at some point I collapsed. It was in a village, in the middle of the street. And that was the moment. Lying there I saw people at a table through a window and eating cheese sandwiches. There was a bluish flicker, the TV, and a boy laughed. A dog barked around the corner or in my head. And then I saw a few people standing around me, they didn't see me. Then it was settled.

Statements made in several conversations recorded with 15-year-old dropouts, shortly after their death.

Interview with the project leader

Question: What evidence did you want to prove with your experiments?

Project leader:

Influences. Influences on the brains of the young test persons.

Can madness still occur today, are there fantasies where there is everything.

And? What can you say in conclusion?

Reality is basically uninteresting.

Thank you.

You're welcome.

PAUL D. MILLER A.K.A. DJ SPOOKY THAT SUBLIMINAL KID

CRITICAL FICTIONS

AN AMBIENT EXPLORATION OF SOME THEMES IN CONTEMPORARY ART IN WHICH ART IS DESCRIBED AS A POLYVALENT, MULTI-THEME CONCEPT

It was one of those strange evenings that are becoming more and more quotidian in the 21st century: It was mid-summer and a concert of Iron Maiden and Queensryche—two towering icons of late seventies and mid-eighties style arena rock sometimes called heavy metal or hair metal, and otherwise just plain old rock and roll—had just finished. Anyway, sitting in the back of a taxi in a traffic jam caused by the crowd exiting Madison Square Garden, summer heat adding layers and layers of "body noise" to the heady mix of the people swirling through the stalled cars and pointillist rendered signs blinking down on the snarled currents of humanity flowing through New York's center, I decided to simply let my mind float and go nowhere fast. I was presented with something that contemporary America seems to have in abundance- a trend I like to call "demographic nostalgia." Each part of the crowd reflected their appreciation of the bands they had come to see and, while stuck in the traffic caused by their migration from the arena, I was given a great point of view on the migratory patterns of the gathered concertgoers. They left the Garden and moved from the finely tuned precision of rows and seat numbers into clumps and clusters of people

Science and Art concur in their eternal search for the Truth... if it were absolutely necessary to provide a metaphor, I would compare the study of natural sciences to the work of archaeologists deciphering inscriptions written in an unknown language, trying out one- -by-one the various meanings of each sign...

E. J. MARET, PARIS, 1894

But of course, there are two kinds of people on earth. One—The people of the towns are more sensible than tortoises. Two—The wild people of the jungles are as senseless as donkeys.

AMOS TUTUOLA, THE WITCH-HERBALIST OF THE REMOTE TOWN, 1981

held together by fashion and social or geographic allegiance like so many particles of gas drawn together by electro-chemical valences and atomic mass. The rules of the "real" world were asserting themselves and the crowd heeded the call of natural selection, 21st century style.

Hypogeal means, "to live underground" in Greek, and it's derived from Hypo which, depending on the context, can mean up or down, and Gaia, which for the most part, means simply "Earth." In some places the word refers to the shadowy underworld of dreams and the dead. In others, it refers to the heavens. Take your pick, but the idea is solidly ambiguous. It's the word in action that makes it an intriguing player on the carnival stage of language. It's one of those strange terms that can take on several connotations, whose meaning depends on the vagaries of language, time, and social placement. "Hypermental," like the term "hypogeal" is made of several layers of interaction, all intriguing, all open to multiple interpretations .. It's the selection of the meanings—how they're woven together—that makes the sense in this kind of sensibility. It's been a hundred and ninety-three years since Hegel wrote his infamous edict on the End of Art as the West knew it back in 1807.[1] It's been a little less time since Marx described the process of Europe's economic industrial expansion as an exercise in social and cultural entropy with his phrase: "All fixed fast frozen relations, with their train of ancient and venerable prejudices and opinions are swept away. All new formed ones become antiquated before they can ossify. All that is solid melts into air, all that is sacred is profaned, and man is at last compelled to face with sober sense, his real conditions of life and relations of his kind."[2] Combine this phrase with Walter Benjamin who wrote in "The Story Teller" about the decline of actual experience, "which teaches us that the art of story telling is coming to an end.... More and more often than not there is embarrassment all around when the wish to hear a story is expressed. It is as if something that seemed inalienable to us, the securest among our possessions, were taken away from us: the ability to exchange experiences. One reason for this phenomenon is obvious: experience has fallen in value.... For never has experience been contradicted more

thoroughly than strategic experience by tactical warfare, economic experience by inflation, bodily experience by mechanical warfare, moral experience by those in power. A generation that had gone to school on a horse drawn street-car now stood under the open sky in a country side in which nothing remained unchanged but the clouds, and beneath these clouds, on a field of force of destructive torrents and explosions, was the tiny, fragile human body."[3]

So here we are, in the 21st Century, and almost all definitions of conventional, normal, boring art have been thrown out the metaphorical window of our ultra saturated info bombarded post-everything minds. To use a folk phrase, we've thrown out the proverbial "baby with the bathwater," and are left with some serious issues on how to reconstruct—if indeed, we should bother at all—some kind of normative situation where art can flourish in a context that it has never really had to face: the real world. For Hegel, as one of Europe's leading figures in contemporary aesthetics, Africans, he wrote in his "Lectures on the Philosophy of Religion" couldn't really make art—they made objects that were utterly referential and transitory (they were outside of the "World Historical People" he always referred to):"Africans switch from fetish to fetish at will (willkürlich) while other people have permanent fetishes."[4] For Hegel, and indeed most of Europe, Africa was a place of Regitur arbitrio i.e. African's were governed by caprice and trickery, and the art objects they created were based on a system of constant flux. It's kind of humorous to view that essay in a contemporary light. There's a great passage in Chinua Achebe's Home and Exile—a series of essays he wrote comparing different forms of literature and arts in Africa and in Europe, where Achebe has been in exile for the last several years. In "My Home Under Imperial Fire" Achebe pulls us into a world where gods are exchanged with time and geography—a world that seems to somehow reflect the hyperconsumer world after the fall of the Berlin Wall in 1989: "I heard for example, that one of Ogidi's neighboring towns had migrated into its present location a long time ago and made a request to settle there. In those days there was plenty of land to go around and Ogidi people welcomed the newcomers, who then made a second

THE INVISIBLE MADE VISIBLE

ON PICTURE-MAKING IN THE SCIENCES

GERO VON RANDOW

The sciences in the late 20th century have undergone a visual turn. From physics and chemistry to biology and medicine, from the study of microscopic worlds to geography, oceanography, astronomy and astrophysics: they all depend on visual procedures, image processing and simulation graphics. What's more, they communicate and form their arguments with the help of pictures.

No one has ever seen a planet outside of our solar system, but the flickering around distant stars has led to the compelling conclusion that there must be planets in orbit around them. No one has ever seen a piece of that ninety percent of matter in the universe, justifying its term "invisible," but the shapes of the galaxies and other phenomena force us to conclude that it exists. Astronomers feed their observations into computer models in order to make pictures of invisible planets and invisible matter. On screen, astrophysicists show us what happens inside a supernova, that is, an exploding star. And Pipilotti Rist takes visitors on impossible journeys in her videos (Mutaflor, 1996), into the interior of her own body, for instance (as seen in her exhibition in Vienna two years ago). When Piero Manzoni made his Socle du Monde (placed upside down and labeled "plinth of the world") in 1961, he turned the whole world into an artefact, but at least he left it as is. Nowadays, however, art and science simulate the natural world with recognizably artificial means.

Making the invisible visible has always been a central aspect of the natural sciences. Think of dissection, the microscope, and the X-ray. But today's combination of physics and computer technology has so inflated the mountain of images in research that it has become necessary to concoct a special means of digging through it, tellingly known as "Data Mining." In the meantime brain research has undertaken to see how we see. Pictorial devices like pet-scans examine what is involved in the process of human vision. Though still relatively crude, the procedure is already well advanced.

Mathematicians observe the emergence of systems from small units, depicted on screen as tiny dots that come together to form clusters of dots; metaphorically speaking, these structures come out of white noise. Countless art products resemble these processes,

HYPERMENTAL
AN EXHIBITION IN
SIX CHAPTERS

Desired objects – Object-like desire

The pictorial media have us firmly under control.

From being the classical site for reflecting on images, art has now become a playground in which to question reality.

"The objective world has been replaced by a selection of images that exist above it and assert themselves as the most objective of all." (Guy Debord)

From an incredibly large spoon flows a bright red liquid–paint itself–as if it were a substantial and yet radiant phenomenon in the middle of the room. It's neither a painting nor an advertisement, but a huge image painted on transparent foil cut in strips (James Rosenquist, *Sauce*, 1967). In terms of classical genres, Duane Hanson's *Housewife* of 1969/70 is equally unclear and ambiguous: Is it an object or a sculpture? What is very obvious is the creative will to "genuinely" imitate a man sitting on a real armchair and hung with objects from real life: a hair-dryer, a dressing-gown and slippers, a cigarette and magazines. One is usually shocked in the face of Duane Hanson's figures because they appear to bear negative values within them like anti-material. As if the visible phenomena had suddenly conquered what is invisible and animating and the latter had made itself scarce forever, taking a humanist view of man with it. ■ By contrast, Jeff Koons has been searching for years for an object that would bring everything together and radiate energy, symbolizing, as it were, the most satisfying object from the world of mass production while at the same time bearing within it the refinement of art and its traditions. Jeff Koons' clearly structured mode of painting allows him to delegate the work without losing control over it, as in paintings like *Pink Bow*, 1995–97; it also allows him to pay homage to light in a choreography of highlights derived from advertising photography and a fusion of Dalí and Hard Edge. ■ Salvador Dalí indulged in an almost fantastic mode of painting quite early on in his artistic career, his aim being to meld distance and proximity and unite weird temporalities–a hyperrealistic painting that did not hark back to the more advanced traditions in painting, but instead further developed the inner images mediated through a "paranoiac-critical" process under the control of reason and with a dutiful craft. Dalí painted the *Portrait of My Dead Brother* in 1963, a screen "phantom kit" image composed of cherries and spheres that at times form an atomic lattice, and with black negative areas from which the image of a bird of prey emerges. ■ Screen prints stand for publication–and for the subversive power that dissipates the private and intimate. ■ Caught or protected in the realm of mirror reflections, of images perpetuating and mutating in the sea? In Richard Hamilton's *Interior I*, 1964, a famous woman from the world of cinema looks out at us, and the room in which we stand is reflected in the mirror that is integrated into the painting. In the 1999 video projection *I Couldn't Agree with You More*, Pipilotti Rist looks constantly at the camera as she walks around a supermarket, and with each decelerated step she takes, the goods on display constantly drift out of sight as if swept away by some ghostly centrifugal force created by the uninterrupted eye-contact between the artist and the spectator. ■ B.C.

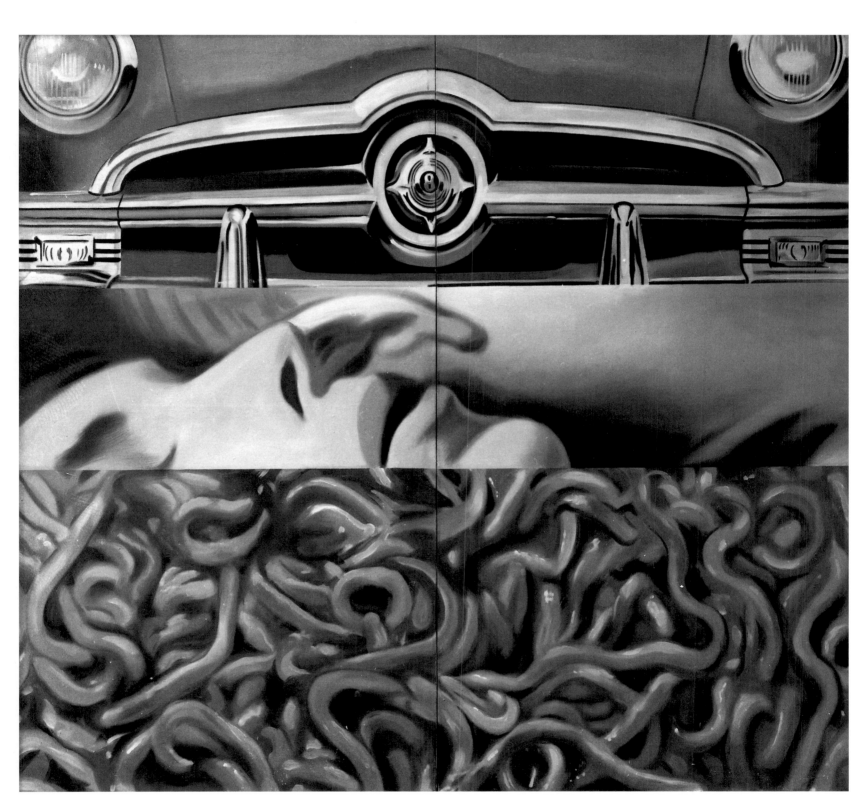

JAMES ROSENQUIST I LOVE YOU WITH MY FORD 1961
Oil on canvas, 82³/₄ x 93¹/₂"
210 x 237.5 cm

50

SALVADOR DALI PORTRAIT DE MON FRÈRE MORT
PORTRAIT OF MY DEAD BROTHER, 1963
Oil on canvas, 69 x 69" / 175.2 x 175.2 cm

ROBERT COTTINGHAM BOULEVARD DRINKS, 1976
Oil on canvas, 78 x 78" / 198 x 198 cm

RICHARD PRINCE UNTITLED (COWBOY), 1994
Ectacolor print, 48 x 72" / 122 x 183 cm

54

JAMES ROSENQUIST SAUCE, 1967
Oil on slit polyester film (mylar)
114 x 70⅞" / 289.6 x 180 cm

JEFF KOONS PINK BOW
Oil on canvas, 102 x 143" / 259.1 x 363.2 cm

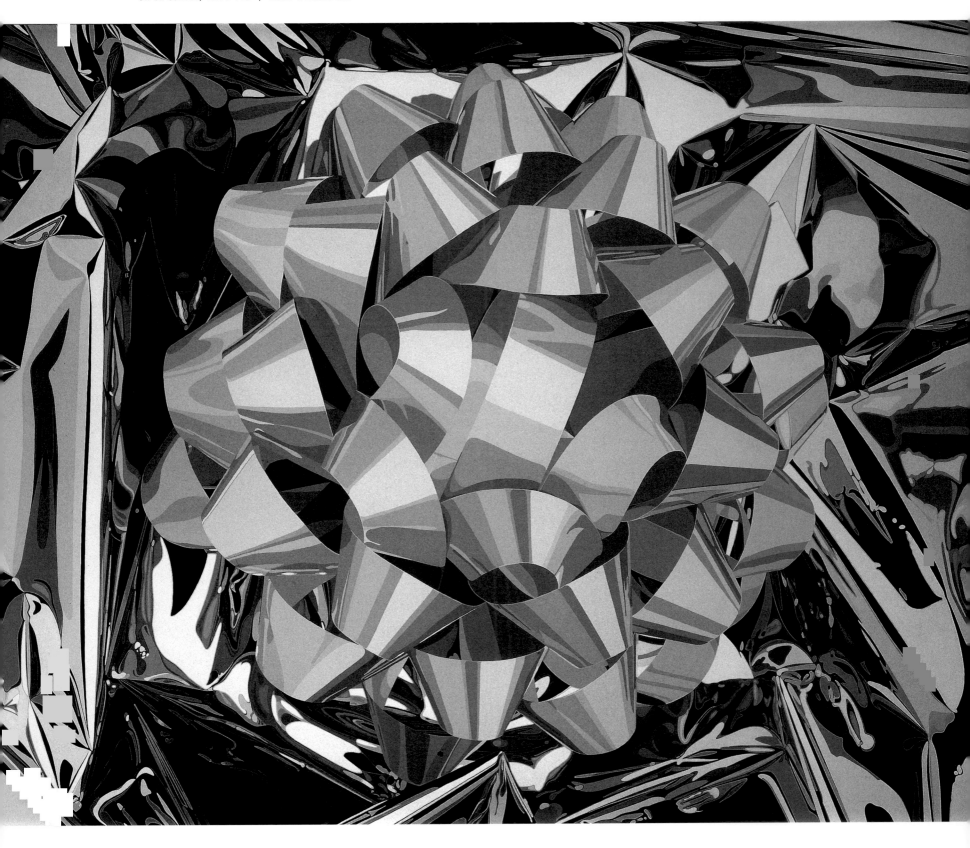

DOMENICO GNOLI SENZA NATURA MORTA
WITHOUT A STILL LIFE, 1966
Synthetic polymer paint and sand on canvas,
53⅛ x 78¾" / 135 x 200 cm

LOWELL NESBITT STUDIO WINDOW I-III (MORNING, NOON, EVENING), 1967
Oil on canvas, in three parts, each 79½ x 59½" / 202 x 151 cm

RICHARD HAMILTON INTERIOR I, 1964
Oil, collage, cellulose on wood, 48 x 64" / 122 x 162.5 cm

PIPILOTTI RIST I COULDN'T AGREE WITH YOU MORE, 1999
Video installation (2 projectors, 2 players, 1 audio system,
sound: Anders Guggisberg), dimensions vary with installation

DUANE HANSON HOUSEWIFE (HOMEMAKER), 1969/
Mixed media, life-size

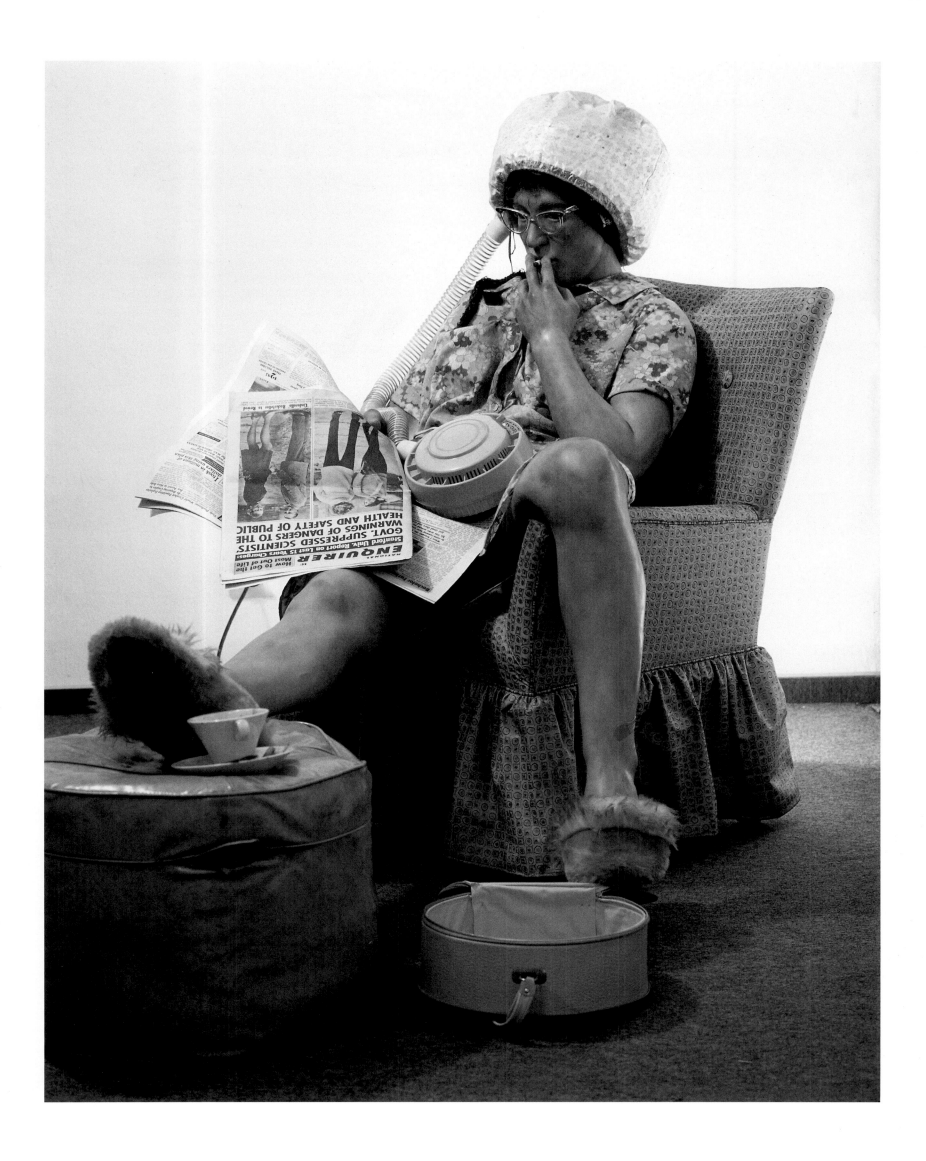

Advertisers Are Cannibals

With the development and expansion of a fully fledged consumer culture, however, advertising became more and more knowingly constitutive of culture, as such. There wasn't a sausage that didn't sizzle superbly or clothes that weren't attractively embodied. And consumers knew it. And because advertisers knew that consumers knew, advertisers have been impelled to further colonize and cannibalize extant cultural mean-

ings in their attempts to construct the signs of distinction. Commodities and meanings, things and ideas about things, have therefore come to seem hopelessly confounded. One of the correlates of such expansion is that there are fewer and fewer locations in which culturally valued meanings might be constructed outside of the market. Those that are—or at least those whose claims to cultural authenticity rest upon such outsider status—

are now either subject to determined efforts at cooptation, or revealed as already implicated, or constructed on the cusp of such a contrast. Examples of this latter now proliferate, ranging from some of Kurt Cobain's lyrics to Andrew Wernick's (1991) ambivalent awareness of how his book on promotional culture is manifestation of the phenomenon that it critiques.

Nick Perry
Hyperreality and Global Culture, 1998

To Spread Rumors

Put ten operators with carefully prepared recordings out at the rush hour and see how quick the words get around. People don't know where they heard it but they heard it.

William Burroughs
The Invisible Generation, 1966

The Security Blanket of Realism

Perhaps the most obvious feature of any rhetoric of realism is its offering of assurance: its suggestion that "yes this is the way things are. " The illustration of the seemingly real lets us know where we stand, what side we're on, and who's winning. As long as sides are being taken and good battles evil, as long as stories are climaxed and laws enacted, we can continue to think that we're in the neighbourhood of ethics, principles, and truth.

Barbara Kruger, Remote Control, 1986

THE REMEDY FOR REALITY LOSS: *REALITY SOAPS!*

Reality Soaps like Big Brother or daily talk shows are the ultimate cultural embodiment of the longing for faithfully detailed self-revelation. But no matter how authentic such shows may seem to be-no matter how sincere the protagonists themselves think they

are-the result is not an unadulterated representation of life. All we ever see are hyper-realistic productions; they do not present a picture of reality but only gratify the craving for a reality that can be captured in moving images, a reality that acts as if it could be easily explained

and easily understood. Shows like Big Brother reveal people's oddly paradoxical fascination with a medial one-to-one duplication of their own daily moods. We escape daily life by immersing ourselves in its virtual reproduction. It is as if one were trying to capture reality in artificially produced authenticity because it is dwindling in real life.

Richard Herzinger, in:
Die Zeit, Hamburg, 18 May 2000

"The program Expedition Robinson is more real than reality."

Heinz Bonfadelli, in:
Tages-Anzeiger, Zürich, 30. 11. 1999

Stabbed for a Pair of Glasses

NEW YORK (dpa). In Manhattan a seventeen-year-old was stabbed for his stylish frames. The young man, wearing glasses currently all the rage among teenagers, was mobbed on a busy street by several youths out to steal them. When he resisted, he was knifed to death.
The thick and heavy frames, which cost about 200 dollars, are currently so popular that young people even wear them without prescription. 16 February, 1984

WANTED: VIRTUAL HANDCUFFS

A hacker gave animal lovers in the USA a scare with the online murder of "Keiko" in Free Willy. The unidentified offender broke into the website of the aquarium in Oregon and reported that the killer whale Keiko of Free Willy fame had been murdered by terrorists. Keiko is actually enjoying the best of health in his bay pen in Iceland.

Metropol, Zürich, 20 June 2000

What Do We Actually See?

Our perception of reality is transformative. Our reality is prestructured. Our new condition is even. Dynamics, fission, and spread weaponry is the familiar aesthetic experience. We reinforce prestructured reality as a means to perceive

reality. Prestructured reality underlines a collective code of motor reactions. Our motor reactions provide subjects for the appropriation by anyone. Our vehicles are primary. Our expressions are absorbed within the first ten seconds. Anything occupying our attention for more than a minute is transgressed.

Richard Prince, War Pictures, 1980

Fraud: *How It Happened!!*

It's not that Kummer would have made a secret of using fakes to run his business. On the contrary, he wrote a book about it in 1997. *Good Morning, Los Angeles. Die tägliche Jagd nach der Wirklichkeit* (The Daily Hunt for Reality) - officially vaunted as a "personal story" and not a novel - is about a Swiss Hollywood print journalist named Tom Kummer, who has a problem because reality has begun to elude the grasp of his profession.

Nils Minkmar, in:
DIE ZEIT, Hamburg, 25 May 2000

Hyperreal Reproduction

Disneyland is more hyperrealistic than the wax museum, precisely because the latter still tries to make us believe that what we are seeing reproduces reality absolutely, whereas Disneyland makes it clear that within its magic enclosure it is fantasy that is absolutely reproduced. The Palace of Living Arts presents its Venus de Milo as almost real, whereas Disneyland can permit itself to present its reconstructions as masterpieces of falsification, for what it sells is, indeed, goods. but genuine merchandise, not reproductions. What is falsified is our will to buy, which we take as real, and in this sense Disneyland is really the quintessence of consumer ideology.

Umberto Eco
Travels in Hyperreality, 1975

No Longer the Obvious Truth

To begin with, reality consists of reports and messages, easily decipherable at times and indecipherable at others. To the extent that scientific research has, however, become more important in all fields, we have imperceptibly been led to stop taking obvious meanings for granted. The sun no longer rises above the earth, the earth is only one body in a galaxy, lost in a sea of galaxies. And humankind on earth is just an organizational form of cosmic matter, which occurs with extreme improbability. And maybe the meat in my hotdog consists of TVP (textured vegetable proteins), made out of soybeans.

Jean-François Lyotard
Les Immatériaux, 1985

> BUT THAT'S SO LAST MILLEN-
> NIUM; FOR THE BLAZINGLY
> FAST PLAYSTATION 2, ANY-
> THING LESS THAN HYPER-
> REALISM IS UNACCEPTABLE.
>
> **Newsweek,** March 6, 2000

A Bad Dream

At the rate that necessity is socially dreamed, the dream becomes necessary. The spectacle is the nightmare of enchained modern society which ultimately expresses its desire to sleep. The spectacle is the guardian of this sleep.

Guy Debord
Society of the Spectacle and Other Films, 1967

Many Flee Homes to Escape: *What for?*

A wave of mass hysteria seized thousands of radio listeners between 8:15 and 9:30 o'clock last night when a broadcast of a dramatization of H.G. Wells's fantasy, "The War of the Worlds," let thousands to believe that an interplanetary conflict had started with invading Martians spreading wide death and destruction in New Jersey and New York. (…)
In Newark, in a single block at Heddon Terrace and Hawthorne Avenue, more than twenty families rushed out of their houses with wet handkerchiefs and towels over their faces to flee from what they believed was to be a gas raid. Some began moving household furniture. Throughout New York families left their homes, some to flee to nearby parks. Thousand of persons called the police, newspapers and radio stations here and in other cities of the United States and Canada seeking advice on protective measures against the raids. (…)
The radio play, as presented, was to simulate a regular radio program with a "break-in" for the material of the play. The radio listeners, apparently, missed or did not listen to the introduction, which was: "The Columbia Broadcasting System and its affiliated stations present Orson Welles and the Mercury Theatre on the Air in 'The War of the Worlds' by H.G. Wells."

New York Times, 30 October 1938

Reality ≠ Reality

If the real is repressed in superrealism, it also returns there, and this return disrupts the superrealist surface of signs. Yet as this disruption is inadvertent, so is the little disturbance of capitalist spectacle that it may effect. This disturbance is not so inadvertent in appropriation art, which, especially in the simulacral version associated with Richard Prince, can resemble superrealism with its surfeit of signs, fluidity of surfaces, and enveloping of the viewer. Yet the differences between the two are more important than the similarities.

Both arts use photography, but superrealism exploits some photographic values (like illusionism) in the interests of painting and excludes others (like reproducibility) not in these interests, indeed that threaten such painterly values as the unique image. Appropriation art, on the other hand, uses photographic reproducibility in a questioning of painterly uniqueness, as in the early copies of modernistic masters by Sherrie Levine. At the same time, it either pushes photographic illusionism to an implosive point, as in the early rephotographs of Prince, or turns round on this illusionism to question the documentary truth of the photograph, the referential value of representation, as in the early phot-texts of Barbara Kruger. Thus the vaunted critique of representation in this postmodernist art: a critique of artistic categories and documentary genres, of media myths and sexual stereotypes. (…)
More importantly, the two approach one another in this respect: in superrealism reality is presented as overwhelmed by appearance, while in appropriation art it is presented as constructed in representation.

Hal Forster
The Return of the Real, 1996

The World No Longer Sphere But Foam

Where everything has become the center, there is no viable center anymore; where everyone transmits messages, the supposedly central transmitter is lost in the confusion of messages. We can see how and why the age of a vast, all-embracing, unified circle and its deferential exegetes has irrevocably expired. The morphological ideal of the polyspherical world that we inhabit is no longer the sphere but rather f o a m. The current worldwide network with all of its protruding virtual realities might thus be said to be structurally indicative of foam rather than mere globalization. In worlds of foam, single bubbles do not converge into one integrating hypersphere, as in metaphysical theories of world, but instead form irregular mountainous congregations. A phenomenology of foams assists us, both conceptually and figuratively, in attempting to define a political amorphology, which gets down to the basics of the metamorphoses and paradoxes of solidarist spaces in an age of diversified media and mobile world markets.

Only a theory of amorphs and unspheres could come up with the most intimate and the most general theory of our present age by studying the current play of the destruction and regeneration of spheres. Foams, piles, sponges, clouds, and eddies provide the first amorphological metaphors, which will help investigate questions of the formation of inner realms, the creation of connections, and immunity architectures in an age of technical Pandora-box complexity. What the media in their confusion are currently praising to death as globalization is, from a morphological point of view, the universalized war of foams.

Peter Sloterdijk, Blasen, 1998

$$x^n + y^n = z^n$$

The exact sciences are conquering Broadway with fun for the public , for, even if people don't understand Heisenberg's quantum theory, they are made to feel as if they do. In the meantime Europe's theater-goers have long given up trying to understand the world with all its murky, shrill, bloody visions of horror although they think they know exactly where they come from: straight out of reality, straight out of what the directors call "real life." But it's quite possible that this "life" is mere semblance and that the mathematicians and astronomers and genetic scientists have begun to write much truer, bloodier and more brutal plays, while we are all nothing but players reciting our biochip lines, and living lives that are no longer dreaming or sleeping (like they used to be) but only a formula.

Gerhard Stadelmaier, in:
Frankfurter Allgemeine Zeitung, 6 June 2000

Manipulation and Seduction

I'm for the return of the objective, and for the artist to regain the responsibility for manipulation and seduction: for art to have as much political impact as the entertainment industry, the film, the pop music and the advertising industries.

Jeff Koons, 1992

CLINTON'S AFFAIRS SPAWN NEOLOGISMS

While editors were squabbling over whether to print terms like "semen" (the *Chicago Tribune* decided to ignore the issue; the *Christian Science Monitor* settled for the euphemism "residue"), late-night comedians had a ball. Entertainers as well as serious reporters gave their country's greatest sex scandal of all time unqualified priority.

The comedians obviously had the advantage: they at least did not have to put on a show of gravity when waxing eloquent about fellatio and traces of semen, with such hits as Oral-Gate, Mastur-Gate, Zipper-Gate, or Tail-Gate.

Christa Piotrowski, in:
Neue Zürcher Zeitung, 6 February 1998

Scientists Propose New Bigfoot Theory

Erik Beckjord of the University of California and head of the Bigfoot research project in San Francisco is convinced: the legendary hominid does exist. In the same breath the scientist adds, "I think it is an extraterrestrial form of life."

in: 20 minuten, Zürich 19 July 2000

Arstist As Savior

The effects of technology do not occur at the level of opinions or concepts, but alter sense ratios or patterns of perception steadily and without any resistance. The serious artist is the only person able to encounter technology with impunity, just because he is an expert aware of the changes in sense perception.

Marshall McLuhan
The Medium is the Message, 1964

Plastic Phantastic!

It is the first magical substance which consents to be prosaic. But it is precisely because this prosaic character is a triumphant reason for its existence: for the first time, artifice aims at something common, not rare. And as an immediate consequence, the age-old function of nature is modified: it is no longer the Idea, the pure Substance to be regained or imitated: an articial Matter, more bountiful than all the natural deposits, is about to replace her, and to determine the very invention of forms. A luxurious object is still of this earth, it still recalls, albeit in a precious mode, its mineral or animal origin, the natural theme of which it is but one actualization. Plastic is wholly swallowed up in the fact of being used: ultimately, objects will be invented for the sole pleasure of using them. The hierarchy of substances is abolished: a single one replaces them all: the whole world can be plasticized, and even life itself since, we are told, they are beginning to make plastic aortas.

Roland Barthes, Mythologies, 1957

Travel Tip:
Virtual Quarter of Tokyo

If you have time on your hands or simply want to go on a discovery tour along paths rarely trodden by tourists, then you should plunge into one of Tokyo's new virtual worlds. Nowhere else can you feel the pulse of Japan with such intensity. Progress fetishism, which bit the dust long ago everywhere else in the world, is still very much alive here. At the same time, the country is completely overcome by hikikomori, meaning the escape from reality into a virtual world, as increasing numbers of young people in Japan retreat into their rooms, stuffed to the gills with gizmos and gadgets.

Konrad Muschg, in:
Tages-Anzeiger, Zürich, 22 June 2000

RICHARD HAMILTON JUST WHAT IS IT THAT MAKES TODAY'S HOMES SO DIFFERENT?, 1994
Color laser print, 9⅜ x 14⅜" / 23.7 x 36.4 cm

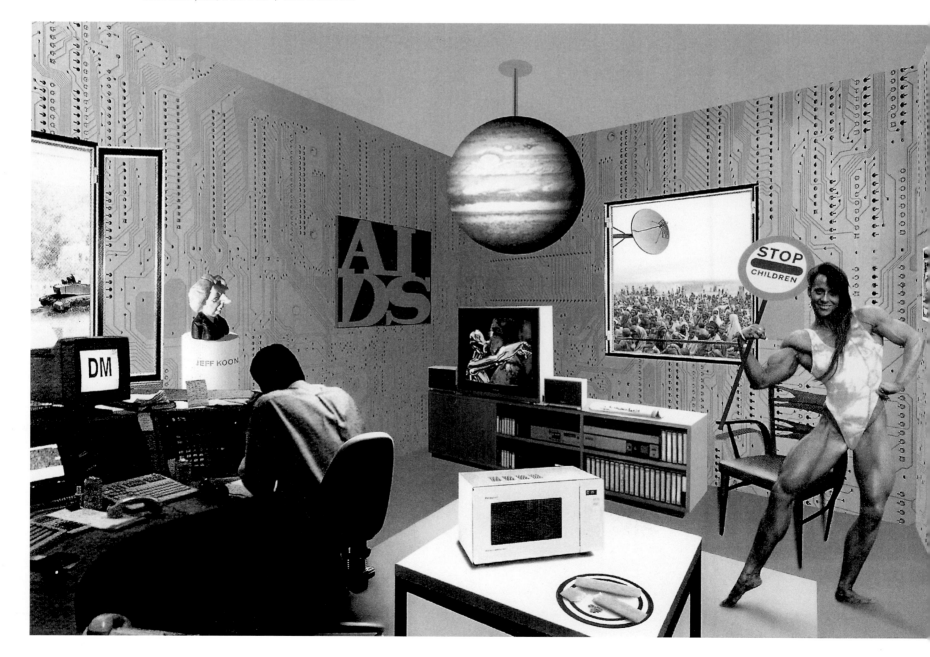

RICHARD HAMILTON JUST WHAT WAS IT THAT MADE YESTERDAY'S HOMES SO DIFFERENT, SO APPEALING?, 1956/1991
Color laser print; electronically restored collage of 1956, 10⁹/₁₆ x 9⁷/₈" / 26.2 x 25 cm

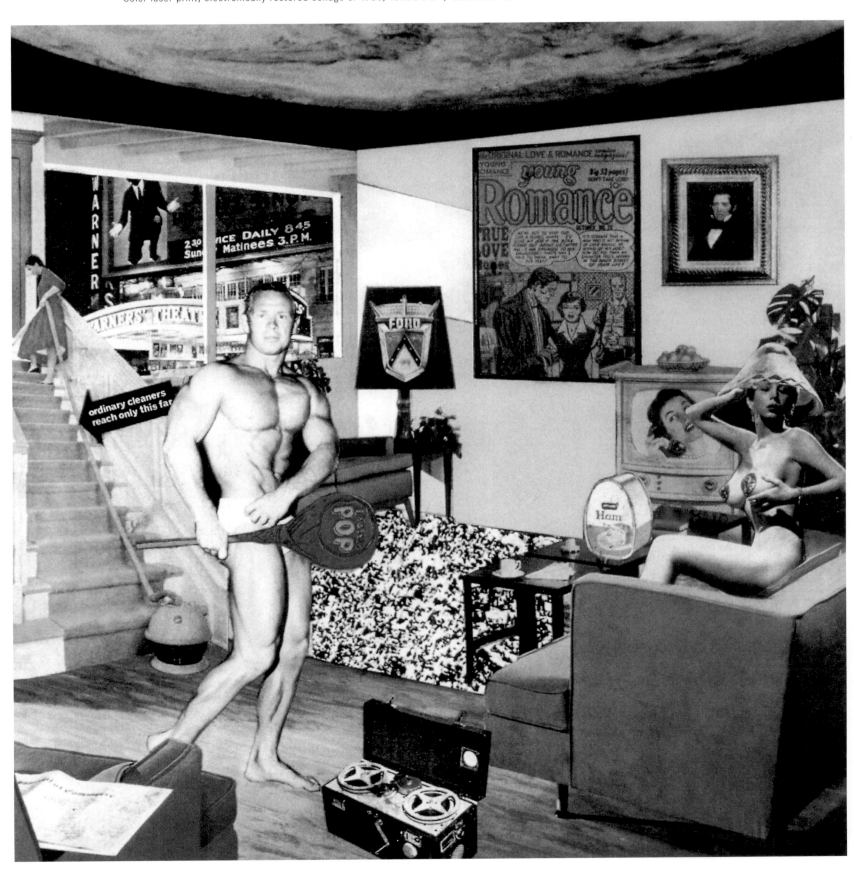

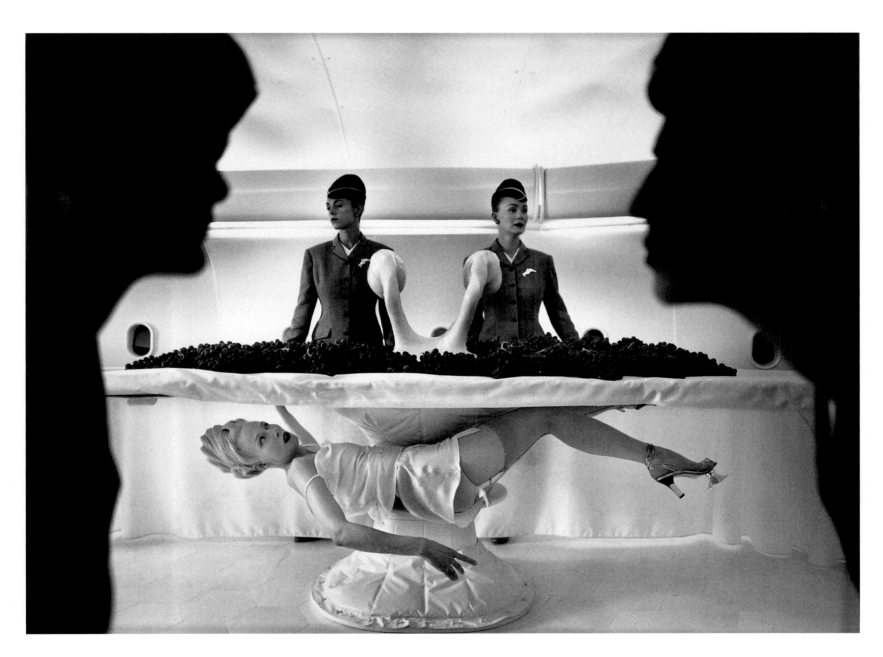

MATTHEW BARNEY CREMASTER 1, 1995
Production still, © 1995 Matthew Barney
Goetz Collection, Munich
Photograph: Michael James O'Brien, Courtesy Barbara Gladstone, New York

Art and Reality

Since the sixties the domain of art has seemed too narrow and too far removed from reality for many artists.

Works have therefore been produced that reached out into the social sphere, striving actively for a direct confrontation with the spectator.

Today too, the social role of art is again being focused on, though without the same expansive impetus as before.

In a globalized world the values of western art, culture and tradition are being questioned again and art works from other cultural contexts are participating in the dialogue on the basis of possible affinities and points of contact.

Yves Klein's leap into the void, *Saut dans le vide*, of 1960 already mimics the new approach of the sixties, which demanded for art an expansion of consciousness and an escape from its protective confines. Klein's daring, based on a photomontage, set its sights on positive life forces for the artist, while simply disregarding the inevitable failure. ■ Piero Manzoni's poetic gesture aimed at subjugating the earth by spiritual force alone, declaring it to be a work of art, as in *Le Socle du monde* of 1961, culminated decade later with Gilbert & George and their self-presentation as *Living Sculptures* in a tranquil and otherwise unspectacular Getting-Drunk-as-Art, à deux, at home in their living room, as witness the video film *Gordon's Makes Us Drunk* of 1972. ■ The set pattern of the modern world has even forced its way into the private sphere. And from the early sixties onwards, Yayoi Kusama has covered furniture, indeed whole interiors, with phallic accumulations, so as to subject them to her own spellbinding magic. ■ In 1963 Konrad Lueg and Gerhard Richter sought Duchamp's objet trouvé and ready-made in their own hometown, so to speak. Instead of bringing things from outside into the museum, the artists occupied a furniture store, that archetypical place in post-war society, in order to bring their Capitalist Realism to life. What they mainly present is their social aspiration as artists: The meta-dwelling in a banal shop was intended to inspire activity as an artistic reflection. ■ By contrast, *Hon*, 1966, constitutes a piece of walk-in furniture in the form of a huge reclining woman, an "exhibition hall" constructed temporarily in the museum and complete with large curves and opulent painting. Erotic matriarchal archaism and pop cheerfulness infiltrate the cool cultural aloofness of the museum from without and from a distant time dimension. ■ What is now to be found in many unexpected actions is a kind of memento for a women's reality which rises up against phallogocentrism (Jacques Derrida). For example, in the harsh re-staging of a rape by Ana Mendieta (1973). And ultimately in Martha Rosler's collage attack (1967–72) on the schizophrenia of the "humanist worldview" in which the reality of war clashes with that of cultivated living in an atmosphere of general indifference. In the "abuse of the public" by Sigmar Polke (*The Large Scolding Cloth*) and Bruce Nauman (*Get Out of This Room*) both 1968, the "authors" too make themselves heard with all those newly formulated scruples about authenticity, and their words seem to ask: Where am I? Who is the public? How effective or how fictional is my lament, my "Expressionism"? ■ Ben Schonzeit (*House, Blown Away*, 1975) and Robert Gober (*Burnt House*, 1980) encircle the ominously damaged house, a metaphor for cultural unease and the feeling of discplacement. ■ Against the backdrop of her experiences as a Korean, Kim Soo-Ja drafts a haunting image of being on the road, of oscillating between autonomy and extraneous control. A majestic figure enthroned on a cart packed with colorful bundles glides slowly through the landscape. A rear view, like the one captured by Erik Bulatov in *Horizon*, 1971–72, shows a group of Soviet city people striding resolutely towards the sea and an ideologically overcast horizon. ■ The strangely hovering, dream-like tempi and shots in the 1997 video installation *Stasi City* by Jane and Louise Wilson invite the spectator on a bewilderingly hypnotic journey through the graphically rendered bowels of the perverse machinery of state oppression. And it would seem as if David Hammons' melancholic objects wanted to institute an awareness of inner peace, of ancient fortifying powers of survival through their aura of being alien in the realm of art. ■ B.C.

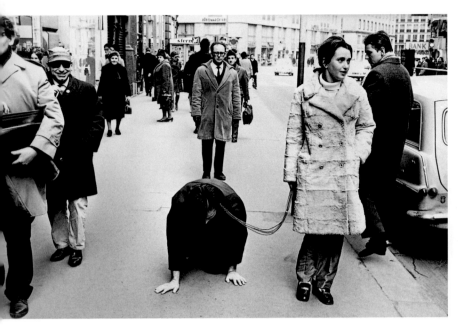

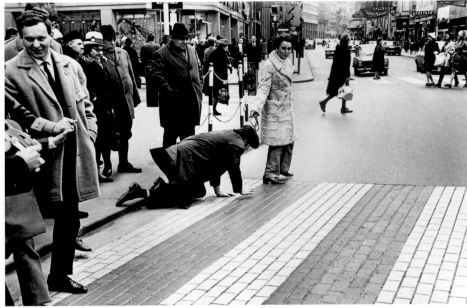

VALIE EXPORT/PETER WEIBEL FROM THE "MAPPE DER HUNDIGKEIT"
"DOGGINESS PORTFOLIO," 1968
Five black-and-white photographs, 15¾ x 19⅝" / 40 x 50 cm each

CHRIS BURDEN SHOOT, 1971
Black-and-white photograph, 8 x 10" / 20.3 x 25.4 cm

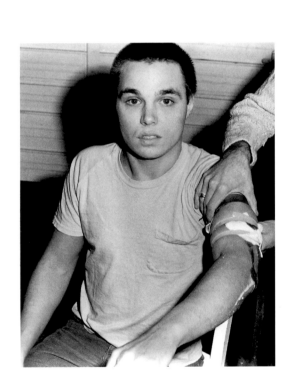

CHRIS BURDEN DEADMAN, 1972
Black-and-white
photograph, 8 x 10"
20.3 x 25.4 cm

VALIE EXPORT TAPP UND TAST KINO, 1968
Black-and-white photograph,
19½ x 23½" / 49.6 x 59.6 cm

CHRIS BURDEN DOORWAY TO HEAVEN, 1973
Black-and-white photograph, 8 x 10" / 20.3 x 25.4 cm

CHRIS BURDEN DOS EQUIS, 1972
Black-and-white photograph, 8 x 10"
20.3 x 25.4 cm

PIERO MANZONI SOCLE DU MONDE/PLINTH OF THE WORLD, 1961
Iron, 32¼ x 39⅜ x 39⅜" / 82 x 100 x 100 cm

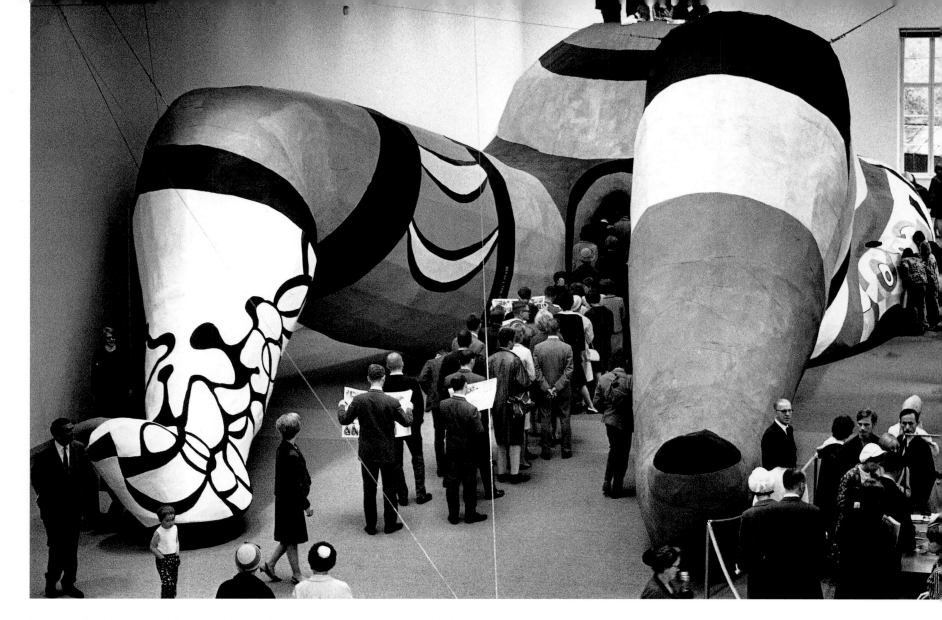

NIKI DE SAINT PHALLE/JEAN TINGUELY/PER OLOF ULTVEDT HON – EN KATEDRAL
SHE – A CATHEDRAL, 4th June – 4th Sept. 1966
Photographs of the exhibition at the Moderna Museet, Stockholm

GILBERT & GEORGE GORDON'S MAKES US DRUNK, 1972
Still from black-and-white video, sound, 12 m.

72

SIGMAR POLKE DAS GROSSE SCHIMPFTUCH/THE GREAT SCOLDING CLOTH, 1968
Tar on cotton sheeting, 157½ x 185" / 400 x 470 cm

ALLAN KAPROW ACTIVITY MODELS: TRANSFER, 1968/71
One of seven photographs from CALENDAR, 1968,
writing added 1971, 45¼ x 45¼" / 115 x 115 cm

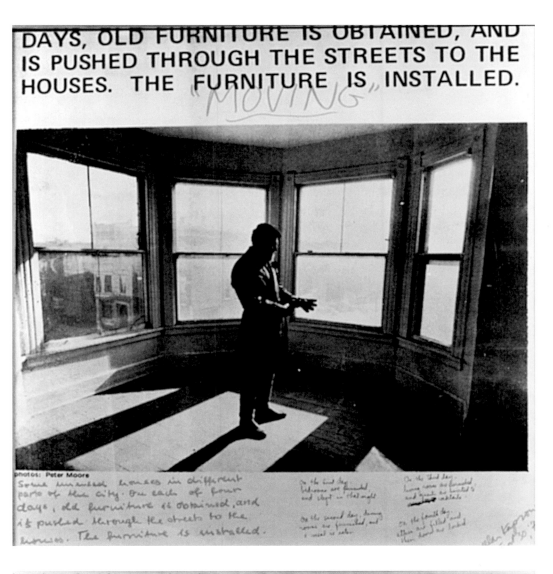

ALLAN KAPROW ACTIVITY MODELS: MOVING, 1968/71
One of seven photographs from CALENDAR, 1968,
writing added 1971, 42 1/8 x 42 1/8"
107 x 107 cm

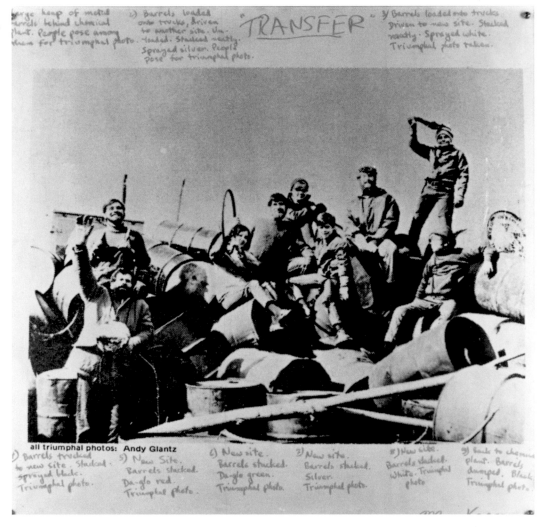

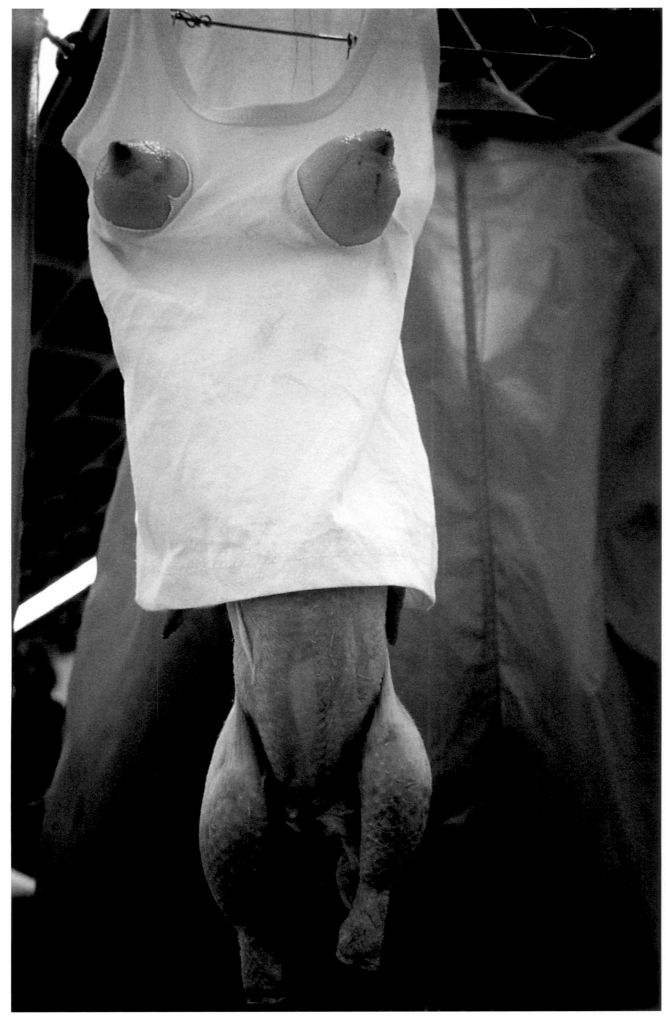

SARAH LUCAS SEX BABY, 2000
R-type-print, 36 x 24"
91.5 x 61 cm

ANA MENDIETA PEOPLE LOOKING AT BLOOD, MOFFITT, IOWA, 1973
Suite of thirty-five color slides documenting performance,
Iowa, May 1973

ANA MENDIETA RAPE SCENE, 1973
Suite of ten color slides documenting performance
at Ana Mendieta's Apartment, Iowa, April 1973

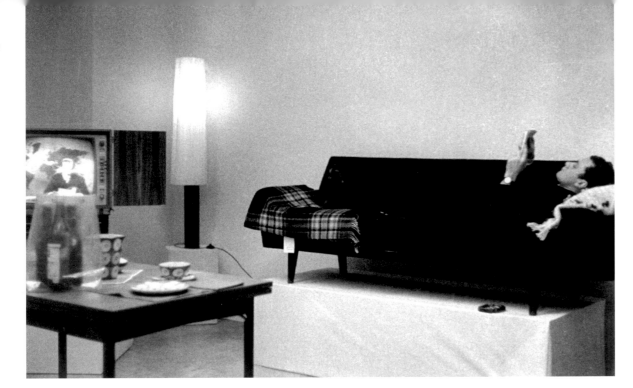

DEMONSTRATION FÜR DEN KAPITALISTISCHEN REALIS-
MUS / DEMONSTRATION OF CAPITALIST REALISM, 1963
Möbelhaus Berges, Berlin, 11th October 1963
Exhibition view: Gerhard Richter, reading a mystery

GERHARD RICHTER / KONRAD LUEG

DEMONSTRATION FÜR DEN KAPITALISTISCHEN REALIS-
MUS / DEMONSTRATION OF CAPITALIST REALISM, 1963
Möbelhaus Berges, Berlin, 11th October 1963
Visitors walking into the exhibition, Gerhard Richter (left),
Wardrobe with Loan from Prof. Beuys on the Wall

GERHARD RICHTER / KONRAD LUEG

DEMONSTRATION FÜR DEN KAPITALISTISCHEN REALIS-
MUS / DEMONSTRATION OF CAPITALIST REALISM, 1963,
Möbelhaus Berges, Berlin, 11th October 1963
Exhibition view: Konrad Lueg (left), Gerhard Richter (right),
monitor showing *news program with Karl-Heinz Köpcke*

YVES KLEIN LE SAUT DANS LE VIDE
LEAP INTO THE VOID, 1960
In Dimanche, 27 Novembre, the
title read: Un homme dans l'esp
ce! Le peintre de l'espace se je
dans le vide!, 1960

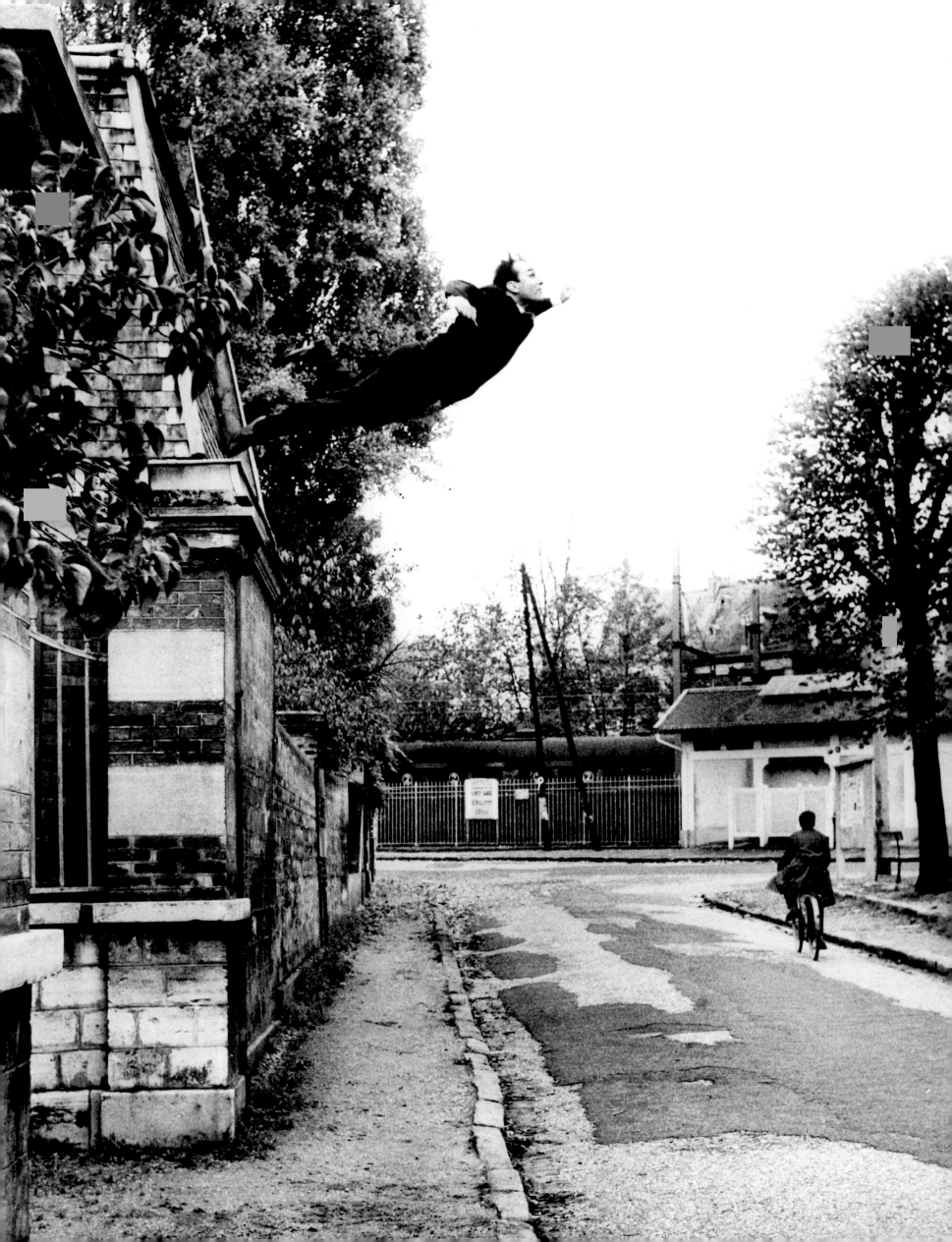

Theatrical Loneliness

My case resembles that of a beggar, who is standing singing on a bridge at midnight in the middle of winter. The passers-by give him nothing because to them begging in that way is a bit too theatrical—this is exactly what passers-by think when they see me leaning on a balustrade, melancholy and idle: I am merely playacting. They're right. And yet, don't you think it's pretty sad to stand begging on a bridge or leaning over a balustrade simply in order to attract attention?

Emmanuel Bove, Mes Amis, 1924

The World behind the Wallpaper

The wallpaper with which the men of science have covered the world of reality is falling to tatters. The grand whorehouse which they have made of life requires no decoration; it is essential only that the drains function adequately. Beauty, that feline beauty which has us by the balls in America, is finished. To fathom the new reality it is first necessary to dismantle the drains, to lay open the gangrened ducts which compose the genito-urinary system that is permanganate and formaldehyde. The drains are clogged with strangled embryos.

Henry Miller, Tropic of Cancer, 1934

Piero Manzoni: subjective

We can therefore say that subjective invention is the only means of discovering objective reality, the only means that gives us the possibility of communication between men.

Piero Manzoni, 1957

Cops Aren't Going to Ask Me My Name

MEAD: But one generation of them didn't create it. It was created by hundreds of generations.
BALDWIN: Of course. But a boy of fifteen doesn't have that perspective, does he? Martin Luther King discovered this himself when he finally went to Chicago: that there was a whole generation of black people whom he was completely unable to touch. Their lives, the lives of black boys in Chicago, were so much different from the lives of black boys in Montgomery, so much more fragmented and in so many ways so much more bitter.
It was so much more devious to say to one of those kids, 'We shall overcome. To say that, with patience, time will do this or that was absolutely meaningless …
I have to understand that, despite the fact that I'm twenty-five years older, I'm still in their shoes. Because the police in this country do not make any distinction between a Black Panther or a black lawyer or my brother or me. The cops aren't going to ask me my name before they pull the trigger. I'm part of this society and I'm in exactly the same situation as anybody else – any other black person – in it. If I don't know that, then I'm fairly self-deluded.

James Baldwin in conversation with Margaret Mead, 1970

WHAT DRAMATIZED RELATIONS SHOULD BE

There are internal problems with what critical art means by "critique." To me, a critique is a philosophical practice which does not just separate good from bad – that is, give answers and make judgements. Rather, it dramatizes the relations between what we want and what we are. When I look back over the last fifteen years, I see a lack of development in the idea of critical art and a failure by artists to appreciate how uncompleted an image has to be, how dramatic it really is. There has to be a dramatic mediation of the conceptual element in art. Withoutthis mediation you have only concepts on the one hand and pictures on the other. Images become a decorative completion of an already fully evolved thought. They are just illustrations. So they are boring, there is no drama. But what makes dramatization possible? I think it is a program or a project that was once called *la peinture de la vie moderne*. I always think of the etchings of Goya underneath which he wrote: "I saw this."

Jeff Wall, 1990

INSTEAD OF BOMBS…

… on North Vietnam, US planes should blitz the population with: plump chickens, shoelaces, chewing gum, tomato paste, hamburgers, bagels, Coca-Cola, safety pins, Beatles records, popcorn, cream puffs, screwdrivers, erasers, 4711 cologne, bras, garters, Kleenex, Polaroid cameras, zippers, marmalade, the New York Sunday Times, lipstick, envelopes, pineapples, plastic flowers, thermometers, cookbooks, flower seeds, postcards of the wall, Holocaust books, constitutional laws, teabags, goldfish, crocheted doilies, freedom bells, coal bags, car covers, hot water bottles, Easter egg paints, coat buttons, offset machines, marzipan pigs, rice.

Wolf Vostell
Happening Manifesto, New York, 26 March 1966

YOU ARE THE SUBJECT MATTER!

… You are the center of interest. No actions are performed here, you are being acted upon. That is no wordplay. You are not treated as individuals here. You don't become individuals here. You have no individual traits. You have no distinctive physiognomies. You are not individuals here. You have no characteristics. You have no destiny. You have no history. You have no past. You are on no wanted list. You have no experience of life. You have the experience of the theatre here. You have that certain something. You are playgoers. You are of no interest because of your capacities. You are of interest solely in your capacity as playgoers. As playgoers you form a pattern here. You are no personalities. You are not singular. You are a plurality of persons. Your faces point in one direction. You are an event. You are the event.

Peter Handke
Offending the Audience, 1965

The Art Does Not Participate!

To many of us who arrived in New York around 1975, a similar situation seemed clearly in place. The stringent informality of Postminimalism had given way to a more academic and aestheticized practice that ultimately had to be understood as denying the achievements on which it was based. And this in turn allowed more room for all the varieties of deliberately dumb, pretty art to receive undue attention. Worse, there seemed little real connection between what was going on in the art world and what was going on elsewhere. Art was caught up in a narcissistic system, self-regarding, self-enclosed, and irredeemably boring.

Thomas Lawson, in:
Nostalgia as Resistance, 1988

"I don't think I am trying to commit suicide. I think my art is an inquiry, which is what all art is about."

Chris Burden, 1975

"THE GREAT ARTIST OF TOMORROW WILL GO UNDERGROUND."
Marcel Duchamp, 1961

In Competition with the Reds

The cold war also meant vast military appropriations for weapons. One of the few American traditions (almost as venerable as the Warner Brothers Christmas layoff) is the secretary of defense's annual warning to Congress at budget time. Since his last request for money, the diabolical Reds are once again about to pass us—or have passed us—in atomic warheads, cutlery, missiles, saddles, disposable tissues. Distraught, Congress immediately responds to this threat with as many billions of dollars as the military feel they need to defend freedom and human dignity for all men everywhere regardless of color or creed—with the small proviso that important military installations and contracts be located in those areas whose representatives enjoy seniority in Congress.

Gore Vidal, West Point, 1973

"The Money of the Absolute"

(...) true violence is the deed of the mind
every creative act contains a real threat
to the man who has dared to perform it
that's how a work touches
the spectator or reader
if the thought refuses to bear down, to do violence
it is exposed to suffering fruitlessly
all the brutalities released by its absence

Jean-Luc Godard, Histoire(s) du Cinéma, 1999

Because Our Psychological Make-up Is Not That of Free People

My problem does not lie in a desire to alter or improve the world. We are cursed in that we cannot touch all of this. If you want to involve yourself, you have to devote your entire life to it. This is no longer art, but becomes an activity that seeks to change this life. But if you involve yourself with art, you are not allowed to touch upon these things. And this is where our position differs completely from that of the artists in the West. Let us take Picasso, the supposed master of the objective world. He had the facility to do what he wanted. He was concerned with transformation, he distorted every object. This is typical of the consciousness of the free person. Why can we not use him as an example? Because our psychological make-up is not that of free people... Our task and the task of our generation is to show that this world depicted as unshakeable, immutable, eternal is not everything. This apparently immutable world here is in fact false, ephemeral and untrue. Real existence is to be found on the other side of the boundary. This explains why that space beyond the picture is so important to me too. For me it is the true existence. The fact that this space exists proves the limitations of the world here. It is static and unchanging but not limitless—and that is its primary feature.

Erik Bulatov in conversation with Ilya Kabakov, Moscow, July 1987

From the Life of a Writer's Ego

Garbage for Everyone.
My Daily Text Prayer.
Diary,
Construction Site for Contemplation,
Existence Experiment.
History of the Moment,
Of Time,
Novel of the Year of Upheaval 1998
(...)
The text owes its look and shape to the Internet, where the book, published in daily installments, emerged bit by bit: piecemeal production; its language to be ordinary, understandable, true to life. And above all the inner economy: the text felt guided and buoyed, anticipated and generated by its thoughts on the mute reader-you, your interest, haste, and impatience. (...)
In the dreamy addressee-oriented keys, a kind of abstract you emerged, whose silence I found appealing and felt guided by, as a rule. As if it were telling me what belongs here and what doesn't. What one wants to read, in which doses, and when enough reading has been done. EVERY genuine reaction made me feel immensely insecure. It immediately became so large and important and demanded immoderate reflection.

Rainald Goetz
Abfall für alle, 1999

LIVING WITH THE THREAT OF A NUCLEAR WAR

That will be the beginning of abstract mass murder. One used to stake one's life against the lives of others; one saw one's dead enemies in close proximity, one could touch their wounds: today one shoots from afar without taking a risk, one dies for nothing. In Washington, in Texas, technicians are preparing the charnel houses of Baku, of Leningrad, without seeing them. Without even imagining them. No heroes, no martyrs: a catastrophe for panic-stricken beasts.

Jean-Paul Sartre, 1946

ALOOFNESS

Indifference is the foreigner's shield. Insensitive, aloof, he seems, deep down, beyond the reach of attacks and rejections that he nevertheless experiences with the vulnerability of a medusa. This is because his being kept apart corresponds to his remaining aloof, as he pulls back into the painless core of what is called a soul the humbleness that, when all is said and done, amounts to plain brutality. There, soured of mawkishness, but of sensitivity as well, he takes pride in holding a truth that is perhaps simply a certainty – the ability to reveal the crudest aspects of human relationships when seduction fades out and proprieties give way before the results of confrontations: a clash of bodies and tempers. For the foreigner, from the height of an autonomy that he is the only one to have chosen when the others prudently remain "between themselves," paradoxically confronts everyone with an asymbolia that rejects civility and returns to a violence laid bare. The brutes' encounter.
Not belonging to any place, any time, any love. A lost origin, the impossibility to take root, a rummaging memory, the present in abeyance. The space of the foreigner is a moving train, a plane in flight, the very transition that precludes stopping. As to landmarks, there are none. His time? The time of resurrection that remembers death and what happened before, but misses the glory of being beyond: merely the feeling of a reprieve, of having gotten away.

Julia Kristeva, Strangers to Ourselves, 1988

ERIK BULATOV HORIZON, 1971/72
Oil on canvas, 59 x 70⅞"
150 x 180 cm

BEN SCHONZEIT HOUSE (BLOWN AWAY), 1975
Acrylic on canvas, 98⅜ x 65½"
250 x 166.5 cm

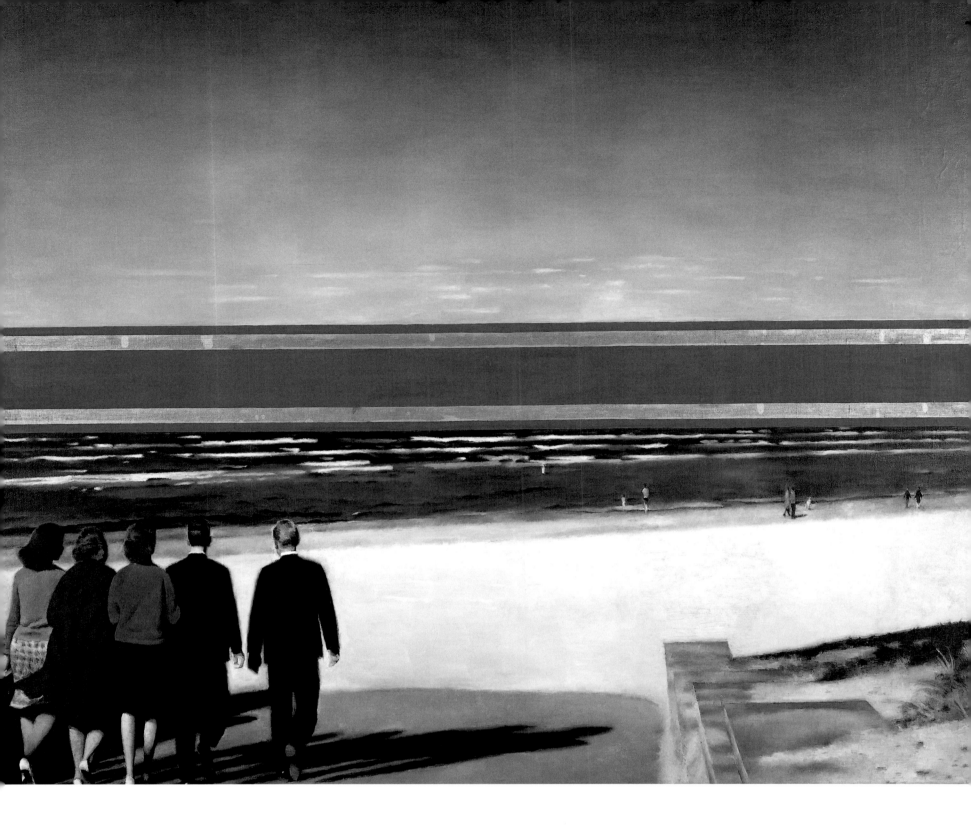

ROBERT GOBER BURNT HOUSE, 1980
Wood, paint, corrugated board, metal,
Plexiglas, linoleum, metal screen, hinges,
wheels, screws, 33 × 26 × 33⅞"
83.8 x 66 x 86 cm

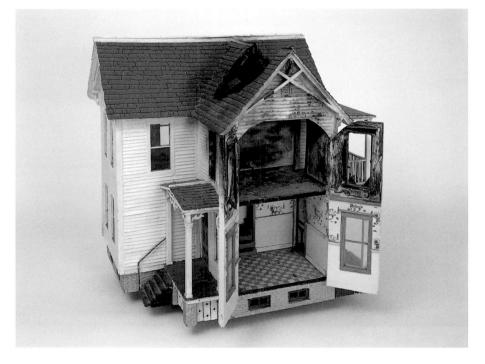

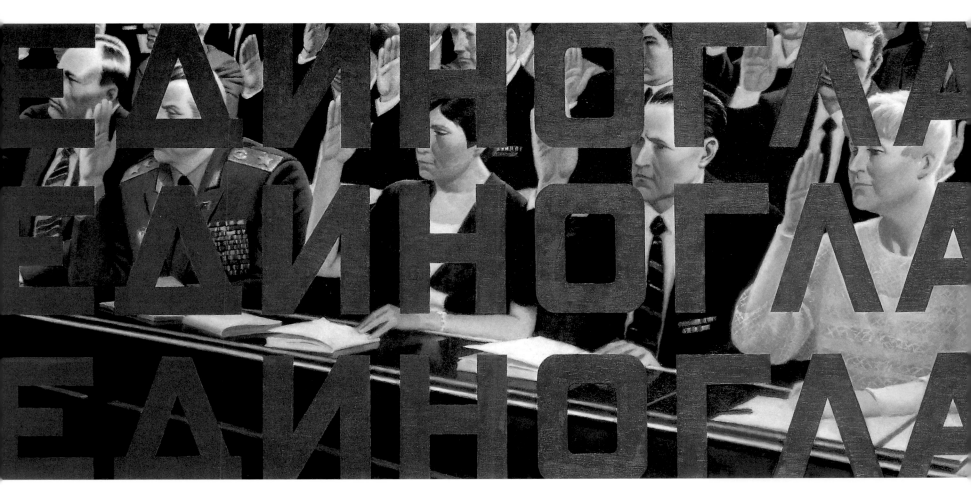

ERIK BULATOV ENDINOGLASNO/UNANIMOUS 1987
Oil on canvas, 31 ½ x 94 ½" / 80 x 240 cm

DAMIEN HIRST WITH DEAD HEAD, 1991
Black-and-white photograph on aluminum, 22½ x 29⅞",
57 x 76 cm

DUANE HANSON RIOT (POLICEMAN AND RIOTER), 1967
Polyester resin and fiberglass, polychromed in oil
accessories, life-size

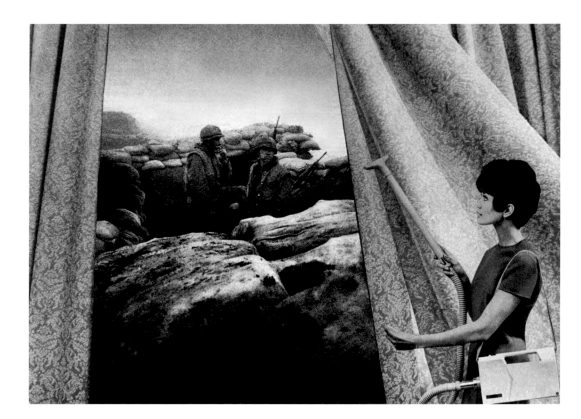

MARTHA ROSLER CLEANING THE DRAPES, 1967-72
From the series *Bringing the War home: House beautyful*,
photomontage, 10¼ x 14" / 26 x 35.6 cm

MARTHA ROSLER BEAUTY REST, c. 1968
From the series *Bringing the War home: House beautyful*,
photomontage, 8⅜ x 8⅜" / 21.3 x 21.3 cm

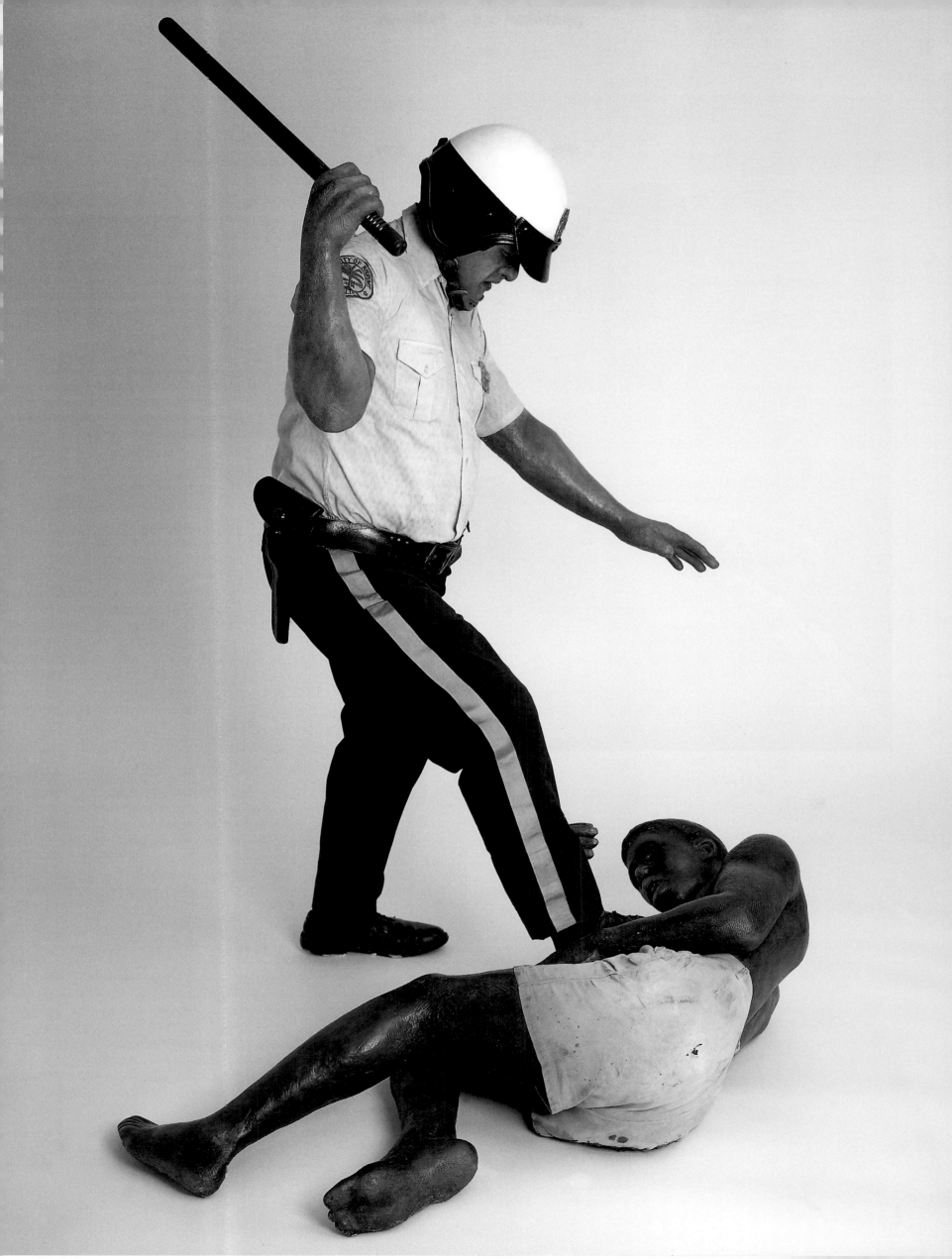

Rrose Sélavy (Eros c'est la vie... et le malheur)

While Marcel Duchamp's art raised the question of the relationship between the sexes, the 20th century also witnessed the emancipation of woman in art, from passive model to reflective and provocative agent. Physicality is being newly defined and explored in anticipation of an as yet unknown hybrid sexuality. As a result of being naturally attached to today's myriad apparatuses and energy sources, borders are shifted, made passable.

Something of the hand-fetish adheres to Marcel Duchamp's fifties' editions of objects, making them altogether offensive. They are imitations or life-size representations of sexual organs and, as casts, play with the idea of positive/negative, of making molds, of turning them inside out. These things aim for the absolute, in the sense that they strip art's motif down to its sex organs. Do the objects represent anti-sublimation, pure and simple? Through the wordplay of the titles–*Objet Dard* (dart, but also work of art)–and through formally integrated allusions–for example, to non-Euclidian geometry–Duchamp imbued his work with so much intellectual liveliness that the opposite can also be claimed. *Prière de toucher* of 1947 is both direct and at the same time ambiguous. What are we being asked to touch, a book, or a breast, or an idea, Surrealism? In 1999, Sarah Lucas replied to Duchamp's work by hanging a photograph of the upper part of her body, clothed in a T-shirt riddled with holes, in the rooms of the Sigmund Freud Museum in London: the real thing, so to speak, at the right place. ∎ In his famous meditation on interiors, the 1956 pop icon *Just what is it that makes today's homes so different, so appealing?*, Richard Hamilton, who also wrote about Marcel Duchamp, defines man and woman in modern society as sexually overdrawn, solipsistic creatures. Years later he presented an updated version of this work for the computer age. ∎ By contrast, Louise Bourgeois would seem to draw her images from times long since past, from behavior patterns that man seems to be unable to cast off. Salvaged for our day, they have preserved their validity, frighteningly enough. ∎ For decades Marcel Duchamp was preoccupied with bachelors who fail to find a bride. As a man, Robert Gober embodies the bride, and in this rite of passage, inconceivable in reality, discovers a ghostly social vacuum caused by the energy of exclusion. ∎ In a world centered around a round paddling-pool, is Eric Fischl's *Sleepwalker* of 1979 sauntering around his adolescent sexuality, while his parents, "objectified" in two empty chairs, seem to scrutinize the scene in their threateningly present absence? Whereas Fischl uses painting to project an "inner film" on the canvas which can then be stopped at just the right moment, the means used by Hans Bellmer to thwart traditional, idealistic modes of representing woman is photography, the apparently most neutral and faithful of media. ∎ To what extent the similarity to humans, the mechanisms of physiognomic beguilement are still operational in lifeless, violently damaged material, in dismembered dolls and stumps, can be seen in Cindy Sherman's photographs, as a kind of morbid state of being beside oneself. ∎ Cameras, video cameras, are all extensions of the body. In *Mutaflor* of 1996, Pipilotti Rist plays with the idea of being organically linked in to the endless circuits of telematic visualization, right into her insides, right into the body's most inaccessible niches. In a loop she swallows a video camera and so despatches it again and again on the journey into the darkness of her intestines. Fragile and transparent, penetrated and extrapolated, the borders have shifted away from the body and into its insides. ∎ Artists like Felix Gonzalez-Torres, however, build up mental force fields, intermediary realms by means of which the intimate, the emotional–symbolized in crumpled pillows or light-blue billowing transparent curtains–appear in unexpected places in the public and social spheres as something being generally lived. ∎ Matthew Barney sets a strangely fascinating machine metaphor, a kind of psycho-biological dynamism in motion, a constantly shifting ornament made up of humans, figures, strange materials, pearls and grapes, motorbikes and Zeppelins, through which glowing figures with their sexuality oddly exposed weave and shimmer like peculiar succulents that only blossom once in a hundred years. ∎ B.C.

LOUISE BOURGEOIS, COUPLE

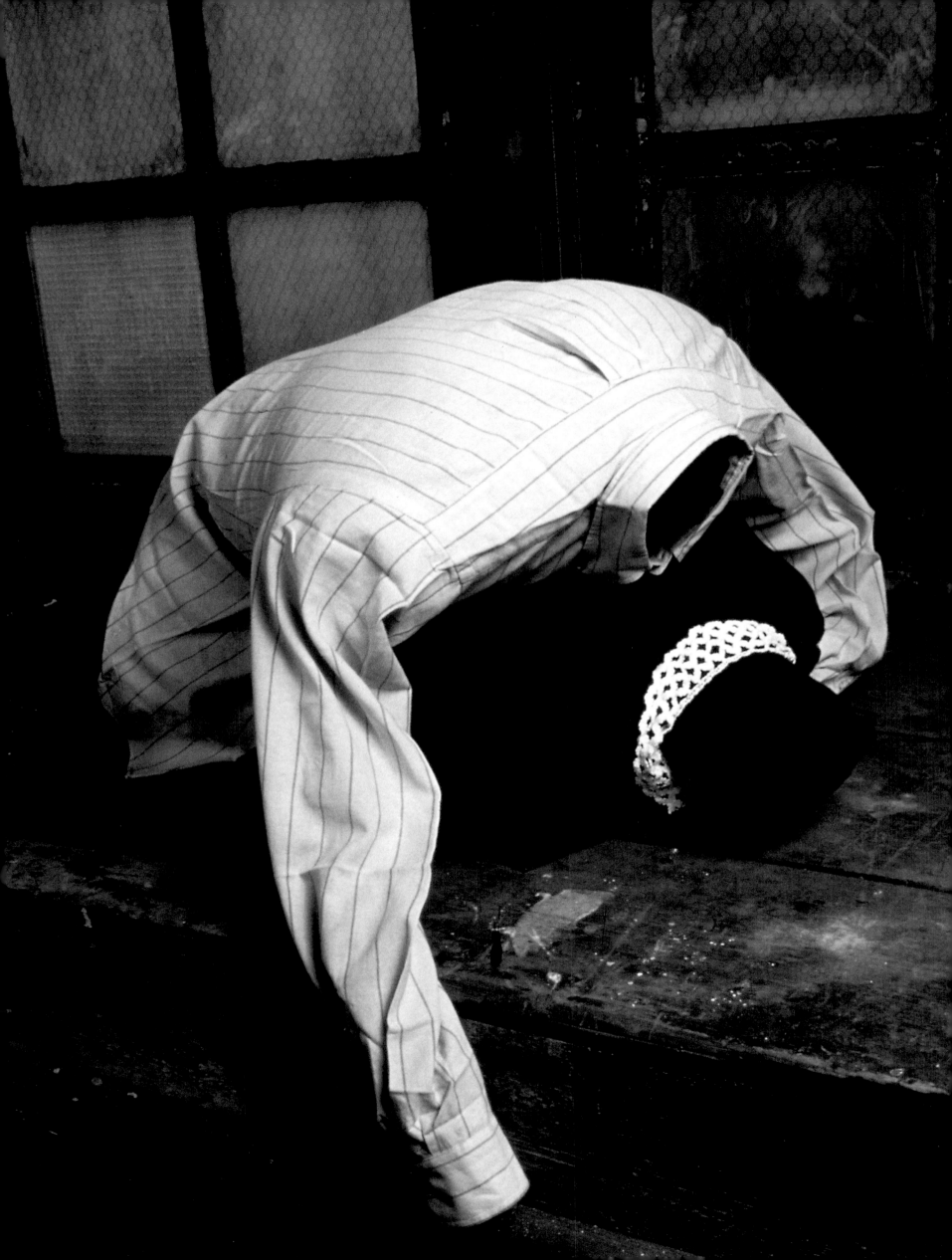

Rrose Sélavy

"In effect, I wanted to change my identity, and the first idea that came to me was to take a Jewish name. I was Catholic, and it was a change to go from one religion to another! I didn't find a Jewish name that I especially liked, or that tempted me, and suddenly I had an idea: why not change sex?

It was much simpler. So the name Rrose Sélavy came from that. Nowadays, this may be all very well—names change with the times—but Rrose was an awful name in 1920. The double R comes from Picabia's painting, you know, the *Oeil cacodylate*, which is at the Bœuf sur le toit cabaret; I don't know if it's been sold —it's the one Picabia asked all his friends to sign. I don't remember how I signed it— it was photographed, so someone knows. I think I put *Pi Qu'habilla Rrose Sélavy*—the word 'arrose' demands two R's, so I was attracted to the second R—*Pi Qu'habilla Rrose Sélavy.*"

Marcel Duchamp, 1965/66

Marcel Duchamp: KING OF GENDERS

In the fifties and sixties Duchamp has been king—the wise man respected by his own generation, held in awe by its sons and wildly adored by theirs. The Midas touch was his—if he had cared in the slightest for gold. Incredibly placed, having simply to point a godlike finger, to bestow on any object the nearest thing to immortality we know; he had only to sign to confer the status of high art on a dustbin. He could have laughed himself to death on the way to the bank without affecting the issue one jot. Instead, he gave life to clay—he made Man (Object Dart), Woman (Female Figleaf), and symbol of their union (Wedge of Chastity). Strangely, the conjunction is not to be fruitful; the nesting "wedge" fits its mould with a sure finality, polarity is brought to negation by their intercourse, master is lost in matrix.

Richard Hamilton, 1965

Gendernauts – *Journey into the Country of New Genders*

Place: San Francisco. Time: now. The experiment: gendernauts, people who live between genders. Just as astronauts roam through outer space and cybernauts through digital networks, gendernauts rove through shifting worlds of sexuality. Transgender, somewhere between male and female. Biological women inject the male sex hormone testosterone in order to acquire a male body and psyche. Their bodies are transformed into something that is beyond man and woman. When asked, "Are you a man or a woman?" gendernauts enigmatically answer, "Yes."

Wed., 1:10 am, Arte

Female Flesh

Woman as spectacle, woman as nude body, as a commodity in films is the new economy of the body, the logic of capital in culture: the body of woman sexualized in films, woman as body ideologized in films is the continuation of the forced labor, the division of labor, instituted in 1800. The image of woman as created in films redefines the body-based distinction between the sexes. The image does not merely represent the social status of woman; it does not merely depict the social position of woman. On the strength of its representation and its imaginary function, the image also molds biologically determined gender distinctions, in keeping with the early capitalist difference between productive and non-productive bodies. The image thus constructs discrimination against woman. The body of woman becomes the image of woman in films to the extent that the history of the film and the history of the body of woman are virtually one. The image of woman in the cinema becomes the woman's body.

Valie Export, 1988

GENDERKILLER LARA CROFT

Lara Croft not only exploits male and female fantasies of empowerment; in the same breath she transforms players of both sexes into users of indifferent gender. Lara Croft, the universal (and, of course, female) means of circulation, erases any qualitative distinction—and that includes gender difference.

Astrid Deuber-Mankowsky, in: Die Wochenzeitung, Zurich, 10 August 2000

Cyberfeminism

Cyberfeminism is (to a greater degree than the term feminism was or its offspring postfeminism or gender studies are) a speculation, a myth, a utopian idea, and a strategic construction. It is above all a discourse of feminist stubborness in the posthuman age of global information and bio technologies. What we have in common first of all is a belief in the viability of this faith, which we attempt to anchor in reality and in our daily lives. And since Cyberfeminism, like feminism, is a politically-motivated, anti-phallogocentric idea, we need to formulate and marshal our understanding of politics in a more concrete way than we have done until now. We believe that Cyberfeminism, incorporating as it does the notion of diversity, is very much an issue of our time, a time of posthumanismand ongoing virtualisation in which words like subjectivity, identity, sex/gender, representation, agency, policy and discourse are undergoing redefinition.

Yvonne Volkart and Cornelia Sollfrank
Next Cyberfeminist International, August 1999

Louise Bourgeois: Women Using Needles

When I was growing up, all women in my house were using needles. I've always had a fascination with the needle, the magic power of the needle. The needle is used to repair the damage. It's a claim to forgiveness. It is never aggressive, it's not a pin. 1992

Deleuze and Guattari Dismantle Sigmund Freud

What does psychoanalysis do, and first of all what does Freud do, if not maintain sexuality under the morbid yoke of the little secret, while finding medical means for rendering it public, for making it into an open secret, the analytic Oedipus? We are told, "See here, it's quite normal, everybody's like that," but one continues to embrace the same humiliating and degrading conception of sexuality, the same figurative conception as the censors'. It is certain that psychoanalysis has not made its pictorial revolution. There is a hypothesis dear to Freud: the libido does not invest the social field as such except on condition that it be desexualised and sublimated. If he holds so closely to this hypothesis, it is because he wants above all to keep sexuality in the limited framework of Narcissus and Oedipus, the ego and the family. Consequently, every sexual libidinal investment having a social dimension seems to him to testify to a pathogenic state, a "fixation" in narcissism, or a "regression" to Oedipus and to the pre-oedipal stages, by means of which homosexuality will be explained as a reinforced drive, and paranoia as a means of defense.* We have seen on the contrary that what the libido invested, through its loves and sexuality, was the social field itself in its economic, political, historical, racial, and cultural determinations: in delirium the libido is continually re-creating History, continents, kingdoms, races, and cultures. Not that it is advisable to put historical representations in the place of the familial representations of the Freudian unconscious, or even the archetypes of a collective unconscious. It is merely a question of ascertaining that our choices in matters of love are at the crossroads of "vibrations," which is to say that they express connections, disjunctions, and conjunctions of flows that cross through a society, entering it and leaving it, linking it up with other societies, ancient or contemporary, remote or vanished, dead or yet to be born. Africas and Orients, always following the underground thread of the libido.

Gilles Deleuze / Félix Guattari
Anti-Oedipus, 1972
*Sigmund Freud, Three Case Histories (New York: Collier, Macmillan, 1970), p.162

Phallic Dolls

Throughout the '30s Bellmer's great project became his two series of *Poupées* (1936/1949), each of which involved, like an eerily humanoid erector set, the assembling, dismantling, and reassembling of a demountable doll, each new assembly positioned and then photographed in a particular setting—kitchen, stairwell, bedroom, barn loft, woods—before being taken apart once more and reused. Staging, lighting, tinting the photographs to bracket their evidence within the space fantasy, Bellmer casts the dolls again and again as phallic. The doll's hair may be tied in a bow, its feet shod in Mary Janes, but, armless, its torso aggressively swelling with a kind of pneumatic dynamism, it summons up the very image of tumescence. Or again, it is seen merely as two pairs of legs joined end to end, erectile, taut, straddling the trunk of a tree. This doll's body, coded/female but figuring forth the male organ within a setting of dismemberment, carries with it the treat of castration. It is the doll uncanny, the doll as informe.

Rosalind Krauss
The Optical Unconscious, 1993

Are Women Simply Smarter?

Women are actually much more law-abiding than men. At the beginning of the chapter on imprisonment, the Yearbook of Statistics states rather vaguely that our prison population consists "mainly of young, unmarried men." But the statistics that follow are very precise indeed: a mere 7918 of the 58,279 convicted offenders were women. One may therefore conclude that women are far less criminally inclined than men—or that they are quite simply smarter, i.e. too smart to catch red-handed. Whatever the case, the proportions are similar regardless of the crime. Women get less involved in brawls (4167:437), steal fewer cars (1441:79), do not launder as much money (142:23), and never commit rape (320:0). Crimes specific to women like shoplifting (wearing three blouses on top of each other, a handbag full of lipsticks) have unfortunately not been included in the statistics.

Urs Widmer, in: Tages-Anzeiger, Zurich, 22 August 2000

JUDITH BUTLER: Attributes of Gender

If it is possible to speak of a "man" with a masculine attribute and to understand that attribute as a happy but accidental feature of that man, then it is also possible to speak of a "man" with a feminine attribute, whatever that is, but still to maintain the integrity of the gender. But once we dispence with the priority of *man* and *woman* as abiding substances, then it is no longer possible to subordinate dissonant gendered features as so many secondary and accidental characteristics of a gender ontology that is fundamentally intact. If the notion of an abiding substance is a fictive construction produced through the compulsory ordering of attributes into coherent gender sequences, then it seems that gender as substance, the viability of man and woman as nouns, is called into question by the dissonant play of attributes that fail to conform to sequential or causal models of intellibility.

Judith Butler
Gender Trouble, 1990

The Flesh Garden

... is located in a round crater four pyramids spaced around it on higher ground North South East and West. Slowly the tendrils fall away the Phallus goes limp and the boy steps free ... „Over there ass tree" ... He points to a tree of smooth red buttocks twisted together between each buttock a quivering rectum. Opposite the orifices phallic orchids red, purple, orange sprout from the tree's shaft. ... „Make him spurt too" ...The boy turns to one of the bearers and says something in a language unknown to Audrey. The boy grins and slips off his loincloth ... The other bearer followed his movements ...„He fuck tree. Other fuck him"...The two men dip lubricant from a jar and rub it on their stiffening phalluses. Now the first bearer steps forward and penetrates the tree wrapping his legs around the shaft The second bearer pries his buttocks open with his thumbs and squirms slowly forward men and plant moving together in a slow hydraulic peristalsis ... The orchids pulse erect dripping colored drops of lubricant ... „We catch spurts"... The boy hands Audrey a stone jar. The two boys seem to writhe into the tree their faces swollen with blood. A choking sound bursts from tumescent lips as the orchids spurt like veins. The body of a green pink color excretes a milky substance ... The boy draws on parchment gloves ... „You touch him you get sores itch you scratch spread sores feel good scratch more scratch self away"... Slowly the lids open on green pupils surrounded by black flower flesh. He is seeing them now you can tell. His body quivers with horrible eagerness... „He there long time. Need somebody pop him."... The boy reaches up takes the head in both hands and twists it sharply to one side. There is a sound like a stick breaking in wet towels as the spine snaps. The feet flutter and rainbow colors spiral from the eyes. The penis spurts again and again as the body twists in wrenching spasms. Finally the body hangs limp... „He dead now"... The bearers dig a hole. The boy cuts the body down and it plops into the grave...„Soon grow another"... said the boy matter of factly... „over there shit tree"... He points to a black bush in the shape of a man squatting. "Now I show you good place"... He leads the way up a steep path to an open place by one of the pyramids ...In niches carved from rock Audrey sees vines growing in human forms. The figures give off a remote vegetable calm ...„This place of vine people very calm very quiet. Live here long long time. Roots reach down to garden. "

William Burroughs, The Wild Boys, 1971

Louise Bourgeois: Don't Wake Up Sleeping Dogs

The phallus is a subject of my tenderness. It's about vulnerability and protection. After all, I lived with four men, with my husband and three sons. I was the protector. I was also the protector of my brother; he knew it, acknowledged it, and used it. Though I feel protective of the phallus, it does not mean I am not afraid of it. "Let sleeping dogs lie." You negate the fear like a lion tamer. There is danger and the absence of fear. There is no danger and yet no thrill with women. (On Fillette) 1992

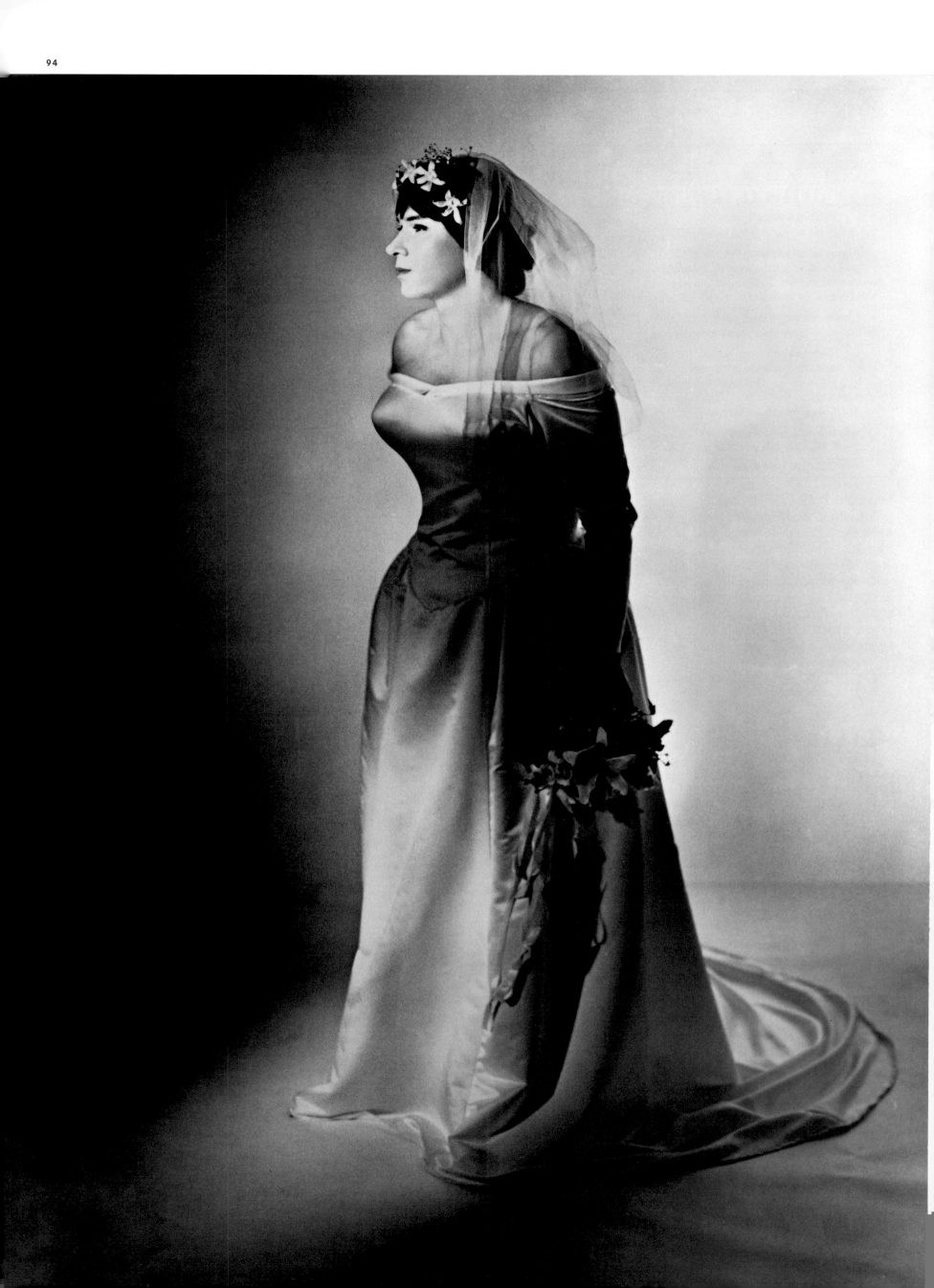

ROBERT GOBER UNTITLED (WEDDING DRESS), 1992/93
Tinted gelatin silver print, 16⅝ x 12¾"
42.5 x 32.5 cm

HANS BELLMER UNTITLED (UNICA ZÜRN), 1958
Gelatin silver print, paper: 9⅜ x 7"
23.8 x 17.7 cm, image: 6⅜ x 6⅜"
16.1 x 16.2 cm

HANS BELLMER UNTITLED (UNICA ZÜRN), 1958
Gelatin silver print, paper: 9⅜ x 7"
23.8 x 17.7 cm, image: 6⅜ x 6⅜"
16.1 x 16.2 cm

HANS BELLMER UNTITLED (UNICA ZÜRN), 1958
Gelatin silver print, paper: 9⅜ x 7"
23.8 x 17.7 cm, image: 6⅜ x 6⅜"
16.1 x 16.2 cm

HANS BELLMER UNTITLED (UNICA ZÜRN), 1958
Gelatin silver print, paper: 9⅜ x 7"
23.8 x 17.7 cm, image: 6⅜ x 6⅜"
16.1 x 16.2 cm

ERIC FISCHL SLEEPWALKER, 1979
Oil on canvas, 69¼ x 105⅛" / 176 x 267 cm

CINDY SHERMAN UNTITLED, 1999
Black-and-white photograph, image:
2½ x 32½" / 54.6 x 82.6 cm,
framed: 29½ x 40½" 75 x 102.9 cm

CINDY SHERMAN UNTITLED, 1999
Black-and-white photograph,
image: 35½ x 23½" / 90.2 x 59.7 cm,
framed: 43½ x 31½" / 110.5 x 80 cm

CINDY SHERMAN UNTITLED, 1999
Black-and-white photograph,
image: 47½ x 31½" / 120.6 x 80 cm,
framed: 55½ x 39½" / 141 x 100.3 cm

PIPILOTTI RIST MUTAFLOR, 1996
Video installation (1 projector,
1 player, no sound), dimensions
vary with installation

HANS BELLMER DIE PUPPE (LES JEUX DE LA POUPÉE)/THE DOLL (THE GAMES OF THE DOLL), 1949
Vintage gelatin silver print, hand-colored on paper, 5½ x 5½" / 13.9 x 13.9 cm

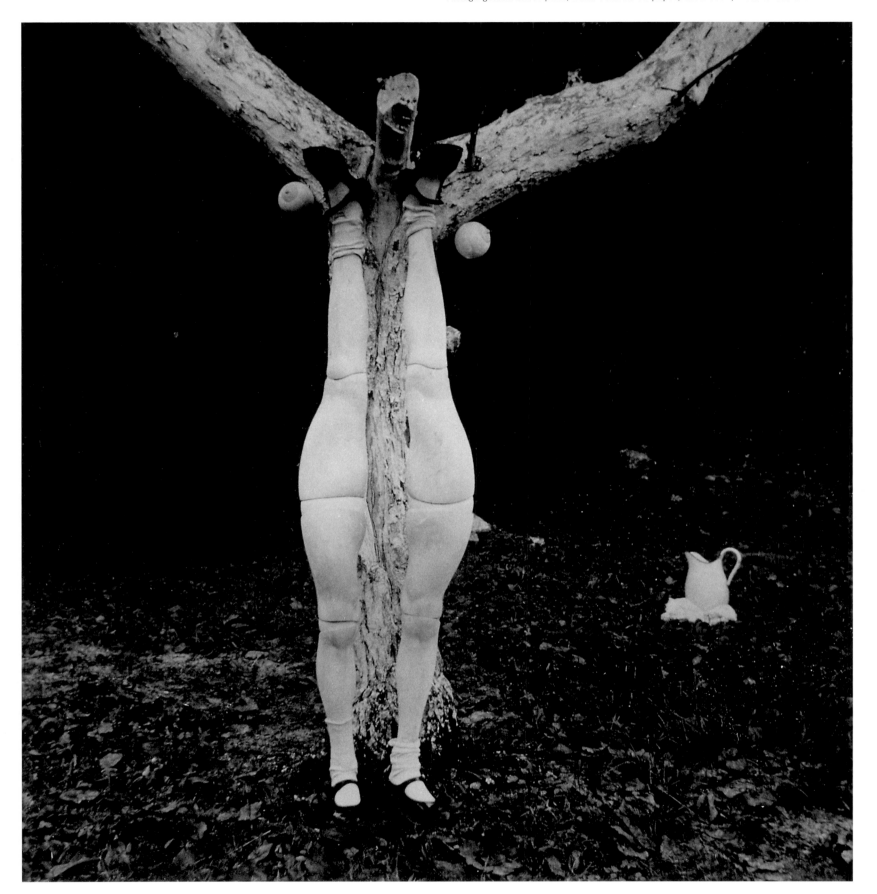

DOMENICO GNOLI BOTTONE/BUTTON, 1967
Oil and sand on canvas, 66⅞ x 51⅛" / 170 x 130 cm

FELIX GONZALEZ-TORRES UNTITLED (CHEMO), 1992
Curtain fabric and metal rod, dimensions vary with installation
Galerie Jennifer Flay, Paris, April 1992

SONY and Surrealism

Surrealism produced a slick, smooth-plastic fake-reality that was later perfected by Sony. In Tokyo I have listened to electronic anthropologists argue that Dalí's graphic "The Persistence of Time" (featuring melting watches) created modern Japanese culture, which no one can deny is eminently surreal.

Timothy Leary, in: Guide to Computer Living, October-November 1986

THE PRINCIPLE OF RUBBER SOUND

Samplers have learned to deform acoustic reality to insane extremes. Almost the entire field of electronic music is now based on this principle of rubber sound.

Jürgen Teipel, in:
Die Zeit, Hamburg, 31 May 2000

✳ Depth When There Is None

It is principally illusions relating to depth which have made us accustomed to considering it as a construction of the understanding. We can produce them by imposing upon the eyes a certain degree of convergence, as at the stereoscope, or by setting before the subject a perspective drawing. Since in this case I imagine that I see depth when there is none, is this not because misleading signs have given rise to a hypothesis, and because generally the alleged vision of distance is always an interpretation of signs? But the postulate is clear; we suppose that it is not possible to see what is not there, we therefore define vision in terms of sensory impression, missing the original relationship of motivating and replacing it by one of signifying. We have seen that the disparity between the retinal images, which stimulates convergence, does not exist in itself; there is a disparity only for a subject who tries to fuse monocular phenomena similar in structure and who tends towards synergy. The unity of binocular vision, and with it the depth without which it cannot come about is, therefore, there from the very moment at which the monocular images are presented as 'disparate'. When I look in the stereoscope, a totality presents itself in which already the possible order takes shape and the situation is foreshadowed.

Maurice Merleau-Ponty
Phenomenology of Perception, 1945

Bridget Riley: Abstraction is the UNIVERSAL Promise

"It will take at least 20 years before anyone looks at my paintings seriously again," Riley predicted.
She was wrong. It took more than 30, in America at least. (...)
In the 60s it was that she had to do with Dean Shrimpton and Op underwear. Wow, it's postfeminism, postmodernism and 60s retro chic.

Still, Cézanne would probably have thought the Cubist who emulated him were crazy. "I don't want to get in rows or interfere," Riley says, admitting that an artist can't control the reception of her work. But, being famously outspoken, she then can't help adding that "at the moment we are in the midst of a rather big wave of philistinism." She says abstraction is still the universal promise of the modern age, what Christian imagery used to be: a "potentially very powerful answer to this spiritual challenge of an unavailable truth, a means of expression beyond limits."

Michael Kimmelman, in:
New York Times Magazine, 27 August 2000

PHANTOM LIMB:

AN ILLUSION OF THE PRESENCE OF AN AMPUTATED LIMB, WHICH MAY BE ASSOCIATED WITH PAIN, ACHES, OR PARAESTHESIA*...

*PARAESTHESIA1:

ABNORMAL SKIN SENSATIONS VARIOUSLY DESCRIBED AS TINGLING, PRICKLING, BURNING, OR 'LIKE PINS AND NEEDLES'.

Oxford Companion to Medicine, 1986

THE BOMBED EYE

It is apparent that some of the most stimulating effects of movement and illumination occur when, because of sequential changes in the spacing or size of units or because of adjustments in viewing position, clear separations begin to merge in a common tone, either light or dark. When these effects appear in certain linear and radial figures, the impression of brightness and pulsation can reach a startling intensity. The eyes seem to be bombarded with pure energy, as they are by Bridget Riley's *Current* (1964). Even effects of color can result – usually pale pink, gold, or blue. These are increased, Gerald Oster has determined, under the influence of the drugs mescaline and LSD. (...)

Can such works, that refer to nothing outside themselves, replace with psychic effectiveness the content that has been abandoned? What are the potentialities of a visual art capable of affecting perception so physically and directly? Can an advanced understanding and application of functional images open a new path from retinal excitation to emotions and ideas?

William C. Seitz, The Responsive Eye, 1965

> *A better term than "artificial intelligence" would have been "simulated cognition."*
>
> **John R. Searle,** 1997

⟶ MESCALIN: "OUT THERE" AND "IN HERE"

But what happens to the majority of the few who have taken mescalin under supervision can be summarized as follows:

Though the intellect remains unimpaired and though perception is enormously improved, the will suffers a profound change for the worse. The mescalin taker sees no reason for doing anything in particular and finds most of the causes for which, at ordinary times, he was prepared to act and suffer, profoundly uninteresting.

He can't be bothered with them, for the good reason that he has better things to think about.

These better things may be experienced (as I experienced them) "out there," or "in here," or in both worlds, the inner and the outer, simultaneously or successively. That they are better seems to be self-evident to all mescalin takers who come to drug with a sound liver and an untroubled mind.

Aldous Huxley
The Doors of Perception, 1954

Polyurethane, Ø c. 47 " / 120 cm; height: c. 71" / 180 cm

The collective neuroti-cized gaze – Common property on call at any time

Mass culture gives rise to myths and forms of conditioning which, as a comprehensively binding pool, continue to influence us like a common education system.

The coins in Katharina Fritsch's floor sculpture *Geld mit Herz (Money with Heart)* sparkle like tiny mirrors and comprise an image of wondrous proliferation as if we were in the company of Uncle Scrooge McDuck. The outline is clearly of a heart conforming to an inscribed geometric form. As is often the case with works by Katharina Fritsch, it only takes seconds for this image to impress itself on our mind as the shell of a semantically insoluble kernel. And it is this insolubility which causes the image to pulsate constantly. Is it a symbol for "Capitalism with Feeling" perhaps? Have feelings become rigid? Is it ratio or purity of emotion that shines so bright and clear? ■ Whereas Katharina Fritsch builds up her pictorial vocabulary on highly effective transfers of meanings, only to contravene the usual mechanisms of visual legibility inside the works, in *I Shop therefore I Am* of 1987 Barbara Kruger's corroded criticism of culture goes directly "on air" on those message and reception channels which rely on us surrendering our life unquestioningly to extraneous control and thereby perhaps even ceasing to know that we exist at all. ■ Our gazes are volatile, as passers-by and media consumers we are persecuted, damned to look at, look back, and look away. What is faded out from this engulfing stream crops up again in art. In this sense, Jeff Wall's light box *Insomnia,* 1994, throws light on a night-time scenario in human. Richard Prince is drawn to the suburban sub-cultures, the archaism of which is regarded as "vulgar" and usually only given any attention socially when packaged in negative headlines. ■ Olaf Breuning's absurd-adolescent fantasy scenes of brand-name conscious, club-swinging cavemen are both uncanny and funny, because, like members of some kind of sect, these grotesque figures always seems to know more than we do. ■ In *Roseville* and *Deep South,* both 1999, Damian Loeb captures instantaneous painted scenes, feverishly catastrophic dreams that seem to be pervaded by an evil gas. What gave rise to the apprehension is in the air, so to speak, though excluded from the image. ■ Doug Aitken turns his gaze to "Bollywood," the world's largest film-studio in Bombay, in a video installation consisting of three projectors in a tent carpeted with sand. By photographing this powerful myth-machine, which operates 24-hours a day, and then feeding these "stills" into the subtly rhythmical circuit of a video installation, Aitken deliberately confuses the time sequences. Sometimes the sound track exerts a great force of attraction, leads a life of its own, while the moving image-montage grants and promotes entry and exit to and from the "dream machine" of cinema and of exoticism. ■ Paul Pfeiffer processes documentary video footage of the sports event of the last century: the final round in the boxing match between Cassius Clay and Sonny Liston on 25 February 1964. In doing so he renders the protagonists themselves invisible or cuts them out, while "exposing" the roaring crowd in the audience. The video installation itself fills the room with great tension by the fact that the flat screen seems suspended in space at the end of a steel rod aggressively jutting out into the room. ■ In *Untitled (Ultra Violence)* of 1999 Dirk Skreber has painted a diagonal view from above of a huge housing complex; an angle of vision obtained from a helicopter which in press photography usually holds out the promise of some disaster or crime. ■ In his 1998 video *Dead Right / Dead Left,* Douglas Gordon undertakes elementary suggestive observations of himself, of a hand and an arm resting on a sheet. With only the most minimal of shifts he renders a whole range of states, from helplessness to the shameless exercise of power, grippingly visible. Similarly Anna Gaskell also uses white linen to create the location in which the figure of a nurse, a strange cross between devotion and torture, confronts a child dressed in white and displaying its vulnerability ultimately as a shield. ■ B.C.

KATHARINA FRITSCH HERZ MIT GELD/HEART WITH MONEY, 1998/99

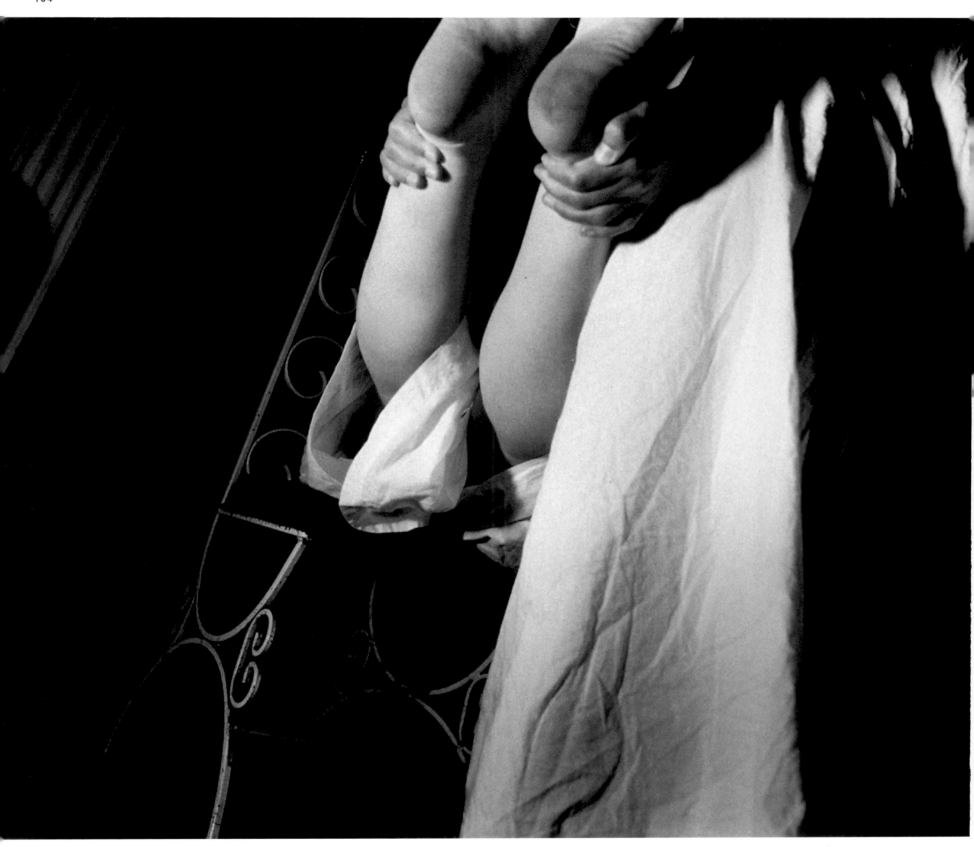

ANNA GASKELL UNTITLED # 41 (HIDE), 1998
C-print, 20 x 24" / 50.8 x 61 cm

DOUGLAS GORDON DEAD RIGHT, 1998
Color video, silent, 60 m.
Goetz Collection, Munich

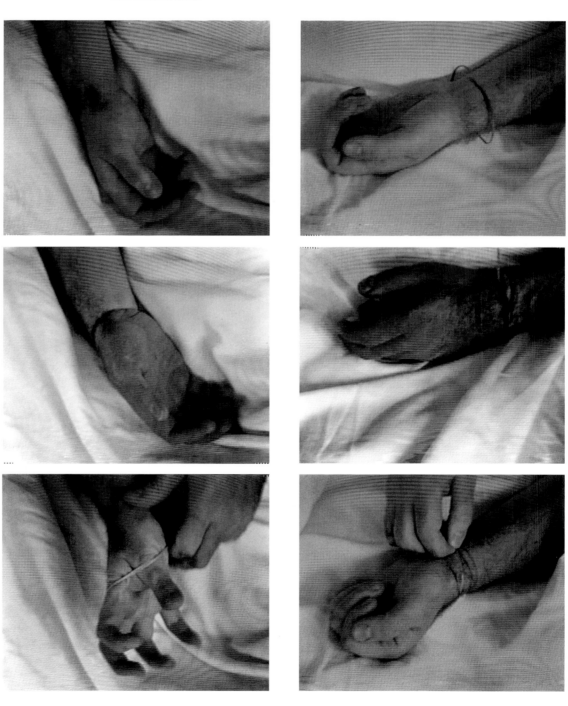

DOUGLAS GORDON DEAD LEFT, 1998
Color video, silent, 60 m.
Goetz Collection, Munich

JAMES ROSENQUIST FOR LAO TSU, 1968
Oil on polyester film (mylar),
118⅛ x 118⅛ x 78¾"
300 x 300 x 200 cm

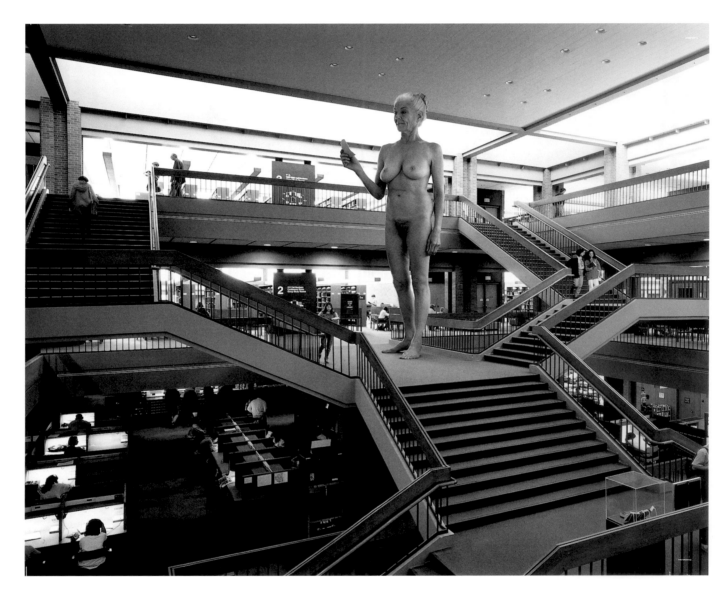

JEFF WALL THE GIANT, 1992
Cibachrome transparency, fluorescent light,
display case, 19½ x 23 x 4¾" / 49.5 x 58.4 x 12 cm

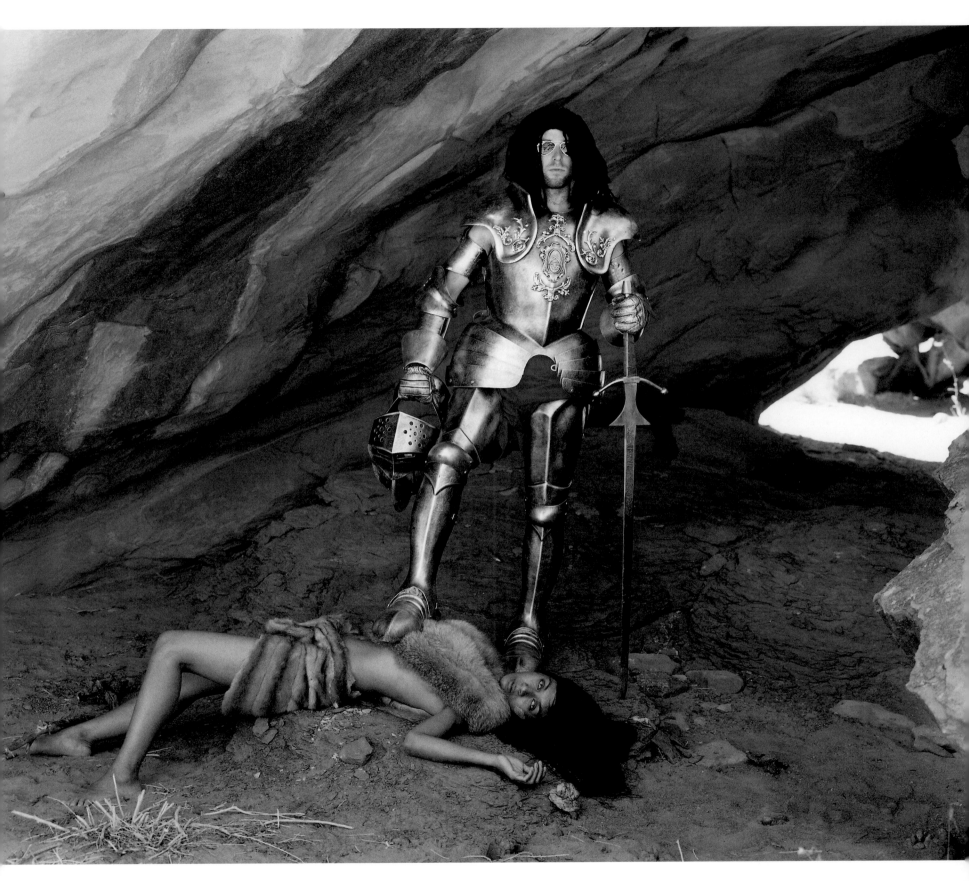

OLAF BREUNING CAVEWOMAN, 2000
C-print, aluminum, laminated, 48 x 61" / 122 x 155 cm

DOUG AITKEN INTO THE SUN, 1999
Still from video installation with 5 projectors,
canvas, sand, dimensions vary with installation

Rays and atoms, the Cosmic

The airy house of modern man: from the tiniest particles to the cosmos. The imaginable and the unimaginable, top speed and weightlessness meet. Man looks into space and from space back to earth.

On the one hand, inconceivable destructive potential, and on the other, feasible fantasies of immense expansion; and still man's cosmic feelings about the "spaceship" that is technology and science prolong old traditions. Or to put it another way: "My mysticism is not only religious, but nuclear and hallucinogenic," says Dalí and paints a cross, in frontal view and in axial symmetry, consisting just of stringent cubes that comply with an intricate numerology. In his unification of square and circle, of smooth technoid primeval form (Dalí's "hypercube") and the simple archaism of bread, we also anticipate Dalí's vision of "Christ pulverized in 888 rays that meld to form a magic nine," as he writes in his *Diary of a Genius*. In their attention to the inside and the outside, Dalí's companions are psychology and physics, Freud and Heisenberg. ■ These days Glenn Brown spends months applying minute brush strokes to fantastic cities that hover in space, and so outdoes in "hyperreality" Dalí's mode of painting from within, so to speak. Glenn Brown's heavenly hovering island machines are also parables of his lonely work in his studio, of an Ego catapulting itself into mythical worlds. As a boy in the seventies, Glenn Brown read books in which he encountered the science fiction illustrator often mentioned in the titles of his paintings, Chris Foss. ■ When Bruce Nauman writes his name "as if inscribed on the surface of the moon" (1968), the outsized letters provide at least the phonetic thrust for projecting identity, that symbol of what is most primal, into the most alien place there is. ■ By contrast, Meret Oppenheim beamed away the features of her identity in her 1964 *X-Ray of My Skull,* with the result that the only thing that can be made out alongside ghostly skeletal bones are jewelery, ear-rings and a ring on a finger. ■ Instead of exposing photographic negatives, Sigmar Polke treated them with Uranium and printed them in a sweet pink. The sight is bafflingly beautiful and unleashes those much-cited mixed feelings, which in this case mean a diffuse fear of the atom that has been handed down over generations and the erotic appeal of the color shocking pink. ■ John Bock works in a pseudo-scientific, muddled universe to which he invites us. A rural crafter of secret entrances of all kinds, who plays with our delight in knowing and our subliminal expectation that great knowledge and insight can be gained in totally unexpected places and in unexpected form—and possibly not in the accustomed supra-institutionalized high-tech streamlined mode. ■ Self-referentiality plays a major role in modern art. When it mutates, as in the work of Matthew Ritchie, it assumes galactic dimensions, where knowledge about knowledge finds expression in painted maps of populated brains, planets, and satellites. ■ B.C.

SALVADOR DALI LA MAXIMA VELOCIDAD DE LA MADONNA DE RAPHAEL
RAPHAEL'S MADONNA AT MAXIMUM SPEED, 1954,
Oil on canvas, 31⅞ x 26" / 81 x 66 cm

GLENN BROWN BÖCKLIN'S TOMB (AFTER CHRIS FOSS), 1998
Oil on canvas, 87 x 130" / 221 x 330.2 cm

BRUCE NAUMAN MY NAME AS THOUGH IT WERE WRITTEN ON THE SURFACE OF THE MOON, 1968
Neon tubing with clear glass suspension frame, in four parts, 11 x 204 x 2" / 27.9 x 518 x 5.1 cm

THE ATOMIC ALPHABET

A for ATOMIC 原子

B for BOMB 爆弾

C for COMBAT 戦闘

D for DUMB 馬鹿

E for ENERGY 原動力

F for FALLOUT 原子灰

G for GUERRILLA 奇襲隊

H for HOLOCAUST 大焼尽

I for IGNITE 発火

J for JUNGLE 密林地帯

K for KILL 殺害

L for LIFE 生命

M for MUTANT 突然変異体

N for NUCLEAR 原子核

O for OBLITERATE 抹殺

P for PANIC 恐慌

Q for QUAKE 地震

R for RUBBLE 粉砕

S for STRIKE 奇襲

T for TARGET 標的

U for URANIUM 重金属元素

V for VICTORY 勝利

W for WAR 戦争

X for RAY 照射線

Y for YELLER 腰抜け

Z for ZERO 零

CHRIS BURDEN THE ATOMIC ALPHABET, 1980
Photo-etching, softground etching, and hand watercoloring, paper: 57½ x 39⅝"
146 x 100.6 cm, plate: 54 x 35½" / 137.1 x 90.2 cm

List of Works

MARINA ABRAMOVIC
RHYTHM 0, 1974/94
Black-and-white photograph framed with text and framed letter
press text panel, edition 13/16, framed: 29 ¾ x 39 ½"
75.5 x 100.3 cm, text framed: 10 ¼ x 7 ¼" / 26 x 18.4 cm
COURTESY SEAN KELLY GALLERY, NEW YORK

DOUG AITKEN
INTO THE SUN, 1999
Video installation (5 projectors, canvas, sand),
dimensions vary with installation
COURTESY 303 GALLERY, NEW YORK
p. 141
Photo: Courtesy 303 Gallery, New York

MATTHEW BARNEY
CREMASTER 1, 1995
Video transferred to laser disc, length: 42' 40",
Director: Matthew Barney, produced by Barbara Gladstone and
Matthew Barney, camera: Peter Strietmann, still photography:
Michael James O'Brien, lead: Marti Domination
© 1995 Matthew Barney
GOETZ COLLECTION, MUNICH
p. 65
Photo: © 1995 Matthew Barney
Courtesy Barbara Gladstone, New York, Goetz Collection, Munich
CREMASTER 1, 1995/96
Plastic case with plastic object and printed laser disc
Case: 53 ¾ x 48 ⅛ x 36" / 136.5 x 122.3 x 91.7 cm;
object: 16 x 20 x 23 ½" / 40.6 x 50.8 x 59.7 cm
© 1995 Matthew Barney
GOETZ COLLECTION, MUNICH
Courtesy Barbara Gladstone, New York

HANS BELLMER
DIE PUPPE (LES JEUX DE LA POUPEE)/THE DOLL
(THE GAMES OF THE DOLL), 1949
Vintage gelatin silver print, handcolored on paper,
5 ½ x 5 ½" / 13.9 x 13.9 cm
FLICK COLLECTION
p. 103
Photo: A. Burger, Zurich
UNTITLED (UNICA ZÜRN), 1958
Gelatin silver print, paper: 9 ⅜ x 7" / 23.8 x 17.7 cm,
image: 6 ⅜ x 6 ⅜" / 16.1 x 16.2 cm
Published by Galerie François Petit, Paris, 1983
Printed by Roger Vulliez from Bellmer's negatives
COLLECTION OF HILTON ALS, COURTESY UBU GALLERY, NEW YORK
p. 97
Photo: Courtesy Ubu Gallery, New York
UNTITLED (UNICA ZÜRN), 1958
Gelatin silver print, paper: 9 ⅜ x 7" / 23.8 x 17.7 cm,
image: 6 ⅜ x 6 ⅜" / 16.1 x 16.2 cm
Published by Galerie François Petit, Paris, 1983
Printed by Roger Vulliez from Bellmer's negatives
UBU GALLERY, NEW YORK
p. 97
Photo: Courtesy Ubu Gallery, New York
UNTITLED (UNICA ZÜRN), 1958
Gelatin silver print, paper: 9 ⅜ x 7" / 23.8 x 17.7 cm,
image: 6 ⅜ x 6 ⅜" / 16.1 x 16.2 cm
Published by Galerie François Petit, Paris, 1983
Printed by Roger Vulliez from Bellmer's negatives
UBU GALLERY, NEW YORK
p. 97
Photo: Courtesy Ubu Gallery, New York
UNTITLED (UNICA ZÜRN), 1958
Gelatin silver print, paper: 9 ⅜ x 7" / 23.8 x 17.7 cm,
image: 6 ⅜ x 6 ⅜" / 16.1 x 16.2 cm
Published by Galerie François Petit, Paris, 1983
Printed by Roger Vulliez from Bellmer's negatives
UBU GALLERY, NEW YORK

p. 97
Photo: Courtesy Ubu Gallery, New York

JOHN BOCK
ARTEMISIASOGJOD→MEECHWIMPER LUMMERIG, 2000
Installation on three levels; moped, vacuum cleaner, video moni-
tors, and more; dimensions vary with installation
FALCKENBERG COLLECTION AT THE HAMBURGER KUNSTHALLE
p. 151
Photo: Courtesy Klosterfelde Gallery, Berlin

LOUISE BOURGEOIS
COUPLE, 1996
Fabric, figure: 17 x 35 x 40" / 43.2 x 88.9 x 101.6 cm; glass and
wood vitrine: 60 x 44 x 38" / 152 x 112 x 97 cm
PRIVATE COLLECTION, COURTESY CHEIM & READ, NEW YORK
p. 91
Photo: Peter Bellamy
FILLETTE (SWEETER VERSION), 1968; cast 1999
Latex over plaster, 23 ½ x 10 ½ x 7 ¾" / 59.7 x 26.7 x 19.7 cm,
edition 2/3
HAUSER & WIRTH COLLECTION, ST. GALL, SWITZERLAND
p. 106
Photo: Christopher Burke

OLAF BREUNING
OHNE TITEL/UNTITLED, 2000
Video installation (player, beam, sound system, knight's armor),
dimensions vary with installation
COURTESY ARS FUTURA GALLERY, ZURICH
pp. 128, 140
Photo: Olaf Breuning, Courtesy Ars Futura Gallery, Zurich

GLENN BROWN
BÖCKLIN'S TOMB (AFTER CHRIS FOSS), 1998
Oil on canvas, 87 x 130" / 221 x 330.2 cm
PRIVATE COLLECTION
pp. 148/149
Photo: Courtesy Patrick Painter, Inc., Santa Monica, CA
HEART AND SOUL, 1999
Oil on wood panel, 40 ⅜ x 33" / 102.5 x 84 cm
PRIVATE COLLECTION
p. 134
Photo: Courtesy Patrick Painter, Inc., Santa Monica, CA

ERIK BULATOV
HORIZON, 1971/72
Oil on canvas, 59 x 70 ⅞" / 150 x 180 cm
CLARA MARIA SELS GALLERY, DÜSSELDORF
p. 81
Photo: Courtesy Clara Maria Sels Gallery, Düsseldorf
ENDINOGLASNO/UNANIMOUS, 1987
Oil on canvas, 31 ½ x 94 ½" / 80 x 240 cm
EMANUEL HOFFMANN-STIFTUNG, ON DEPOSIT
AT THE MUSEUM FÜR GEGENWARTSKUNST, BASEL
pp. 84/85
Photo: Öffentliche Kunstsammlung Basel, Martin Bühler

CHRIS BURDEN
CHRIS BURDEN DELUXE PHOTO BOOK, 1971-73
Portfolio with 53 photographs of performances, each 8 x 10",
20.3 x 25.4 cm, edition 15/50
ZELLWEGER LUWA AG COLLECTION, USTER, SWITZERLAND
pp. 68, 69
Photo: Gary Beydler (Deadman), Courtesy of Chris Burden (Dos Equis),
Charles Hill (Doorway to Heaven), Alfred Lutjeans (Shoot, Prelude),
Diana Zlotnick (Five Day Locker Piece)
THE ATOMIC ALPHABET, 1980
Photo-etching, softground etching and hand watercoloring,
paper: 57 ⅛ x 39 ⅝" / 146 x 100.6 cm; plate: 54 x 35 ½",
137.1 x 90.2 cm, edition 16/20, printed at Crown Point Press,
THE ATOMIC ALPHABET is also a performance: "Like a street tough, dressed all
in black, with a black leather jacket and hat, I appeared spotlit in front of the audi-
ence. Raising my fist and stomping my foot to punctuate each word, I loudly and
aggressively recited an alphabetical list of twenty-six words relating to atomic
destruction [...] The crazed chant ended with the terse cry 'Yeh! Yeh! Yeh!' The
performance lasted 30 seconds." (Chris Burden) It took place
for the first time on 17th November 1979 at the San Francisco

Art Institute and later in several other places.
FLICK COLLECTION
p. 157
Photo: Peter Schälchli Photoatelier

ROBERT COTTINGHAM
BOULEVARD DRINKS, 1976
Oil on canvas, 78 x 78" / 198 x 198 cm
HAMBURGER KUNSTHALLE
p. 52
Photo: © Elke Walford, Hamburg

SALVADOR DALI
CROIX NUCLEAIRE/NUCLEAR CROSS, 1952
Oil on canvas, 30 ¾ x 22 ⅞" / 78 x 58 cm
MARITA MARCH
p. 146
Photo: Jean-Ramon Bonel, Palma de Mallorca
© Kingdom of Spain, universal heir of Salvador Dalí, ProLitteris, 2000, Zurich,
© Gala-Salvador Dalí Foundation by appointment of the Kingdom of Spain,
ProLitteris, 2000, Zurich
LA MAXIMA VELOCIDAD DE LA MADONNA
DE RAFAEL/RAPHAEL'S MADONNA AT
MAXIMUM SPEED, 1954
Oil on canvas, 31 ⅞ x 26" / 81 x 66 cm
MUSEO NACIONAL CENTRO DE ARTE REINA SOFIA, MADRID
p. 145
Photo: Museo Nacional Centro de Arte Reina Sofía, Madrid
© Kingdom of Spain, universal heir of Salvador Dalí, ProLitteris, 2000, Zurich,
© Gala-Salvador Dalí Foundation by appointment of the Kingdom of Spain,
ProLitteris, 2000, Zurich
PORTRAIT DE MON FRERE MORT/PORTRAIT OF
MY DEAD BROTHER, 1963
Oil on canvas, 69 x 69" / 175.2 x 175.2 cm
COLLECTION OF THE SALVADOR DALI MUSEUM, ST. PETERSBURG,
FLORIDA, USA
pp. 50/51
Photo: Salvador Dali Museum St. Petersburg, Florida, USA
© Kingdom of Spain, universal heir of Salvador Dalí, ProLitteris, 2000, Zurich,
© Gala-Salvador Dalí Foundation by appointment of the Kingdom of Spain,
ProLitteris, 2000, Zurich
STUDY FOR "FIFTY ABSTRACT PAINTINGS WHICH AS
SEEN FROM TWO YARDS CHANGE INTO THREE LENINS
MASQUERADING AS CHINESE AND AS SEEN FROM SIX
YARDS APPEAR AS THE HEAD OF A ROYAL TIGER," 1963
Gouache on board, 20 ⅛ x 29 ⅞" / 51 x 76 cm
p. 117
GALA-SALVADOR DALI FOUNDATION, FIGUERES
Photo: Gala-Salvador Dalí Foundation, Figueres
© Kingdom of Spain, universal heir of Salvador Dalí, ProLitteris, 2000, Zurich,
© Gala-Salvador Dalí Foundation by appointment of the Kingdom of Spain,
ProLitteris, 2000, Zurich

KARIN DAVIE
UNTITLED (CURVES) # 1, 1999
Oil on linen, 34 x 48" / 86.4 x 121.9 cm
COURTESY OF THE ARTIST
INTERIOR GHOSTS # 1, 2000
Oil on canvas, 72 x 84" / 182.9 x 213.4 cm
COURTESY MARIANNE BOESKY GALLERY, NEW YORK
p. 122
Photo: Courtesy Marianne Boesky Gallery, New York
RETURN, 2000
Oil on canvas, 72 x 60" / 182.9 x 152.4 cm
COURTESY MARIANNE BOESKY GALLERY, NEW YORK

MARCEL DUCHAMP
FEUILLE DE VIGNE FEMELLE/FEMALE FIGLEAF, 1951
Bronze, one of an unnumbered edition of ten, cast in 1961
3 ¾ x 5 ½ x 5" / 9.5 x 14 x 12.7 cm
COLLECTION OF JASPER JOHNS
p. 95
Photo: Dorothy Zeidman
OBJET-DARD, 1951
Bronze with paint, edition 6/8, 2 ¾ x 8 x 3 ¾",
7 x 20.3 x 9.5 cm

Schwarz Gallery edition of 1962
COLLECTION OF JASPER JOHNS
p. 95
Photo: Dorothy Zeidman
COIN DE CHASTETE/CHASTITY CORNER, 1954
Bronze and dental plastic, edition 7/8, 2 1/8 x 3 1/4 x 1 3/4",
5.4 x 8.3 x 4.4 cm
Schwarz Gallery edition of 1963
COLLECTION OF JASPER JOHNS
p. 95
Photo: Dorothy Zeidman
PRIERE DE TOUCHER/PLEASE TOUCH, 1947
Foam rubber breast and velvet on cardboard cover of the catalog
of the show "Exposition Internationale du Surréalisme," Galerie
Maeght, Paris, July – August 1947, deluxe edition
780/999, 9 7/16 x 8 1/4 x 1 5/16" / 24.1 x 21 x 3.2 cm
COLLECTION OF JASPER JOHNS
p. 95
Photo: Staatliches Museum, Schwerin
VALIE EXPORT
TAPP UND TAST KINO/TAP AND TOUCH CINEMA, 1968
Black-and-white photograph, image: 19 1/2 x 23 1/2",
49.6 x 59.6 cm; frame: 35 3/8 x 39 3/8" / 90 x 100 cm
ZELLWEGER LUWA AG COLLECTION, USTER, SWITZERLAND
p. 69
Photo: Werner Schulz; Archive VALIE EXPORT
TAPP UND TAST KINO/TAP AND TOUCH CINEMA, 1968
Video installation and duplicated information pack
GENERALI FOUNDATION COLLECTION, VIENNA
VALIE EXPORT / PETER WEIBEL
FROM THE "MAPPE DER HUNDIGKEIT",
"DOGGINESS PORTFOLIO," 1968
Five black-and-white photographs, each 15 3/4 x 19 5/8",
40 x 50 cm
GENERALI FOUNDATION COLLECTION, VIENNA
p. 68
Photo: Joseph Tandl; Archive VALIE EXPORT
ERIC FISCHL
SLEEPWALKER, 1979
Oil on canvas, 69 1/4 x 105 1/8" / 176 x 267 cm
PRIVATE COLLECTION,
COURTESY THOMAS AMMANN FINE ART, ZURICH
p. 100
Photo: Courtesy Thomas Ammann Fine Art, Zurich
PETER FISCHLI/DAVID WEISS
Works from the series FIEBER/FEVER, 1983-84
BOITE DE NUIT/NIGHTCLUB, 1983-84
Polyurethane, Ø c. 47" / 120 cm, height: c. 71" / 180 cm
COLLECTION OF THE ARTISTS
MÖNCH/MONK, 1983-84
Polyurethane, Ø c. 47" / 120 cm, height: c. 71" / 180 cm
COLLECTION OF THE ARTISTS
FIEBER/FEVER, 1983
Polyurethane, Ø c. 47" / 120 cm, height: c. 71" / 180 cm
COLLECTION OF THE ARTISTS
L'IDIOT VERT/THE GREEN IDIOT, 1984
Polyurethane, Ø c. 47" / 120 cm, height: c. 71" / 180 cm
COLLECTION OF RUEDI BECHTLER
TOTENKOPF/DEATH'S HEAD, 1983
Polyurethane, Ø c. 47" / 120 cm, height: c. 71" / 180 cm
COLLECTION OF PATRICK FREY
p. 121
Photo: Fischli/Weiss
KATHARINA FRITSCH
HERZ MIT GELD/HEART WITH MONEY, 1998/99
Plastic, aluminum, paint, 157 1/2 x 157 1/2 x 1 1/2" / 400 x 400 x 4 cm
COLLECTION OF THE ARTIST
p. 125
Photo: Nic Tenwiggenhorn, Düsseldorf
Courtesy Matthew Marks Gallery, New York

ANNA GASKELL
UNTITLED #41 (HIDE), 1998
C-print, 20 x 24" / 50.8 x 61 cm, edition 3/3
PRIVATE COLLECTION, SWITZERLAND
p. 136
Photo: Courtesy Casey Kaplan, New York
UNTITLED #50 (SALLY SALT SAYS), 1999
C-print, 50 x 60" / 127 x 152.4 cm, edition 1/3
PRIVATE COLLECTION, SWITZERLAND
UNTITLED #57 (BY PROXY), 1999
C-print, 70 x 60" / 177.8 x 152.4 cm
COURTESY CASEY KAPLAN, NEW YORK
GILBERT & GEORGE
GORDON'S MAKES US DRUNK, 1972
Black-and-white video, sound, 12 m., England/Germany, pro-
duced by: Videogalerie Schum, Berlin, actors: Gilbert & George
COLLECTION OF PAMELA AND RICHARD KRAMLICH, COURTESY OF THEA
WESTREICH ART ADVISORY SERVICES
pp. 70/71
Photo: Susanne Zouyène
DOMENICO GNOLI
SENZA NATURA MORTA/WITHOUT A STILL LIFE, 1966
Synthetic polymer paint and sand on canvas, 53 1/8 x 78 3/4",
135 x 200 cm
STAATLICHE MUSEEN ZU BERLIN, NATIONALGALERIE
p. 56
Photo: Jörg P. Anders, Berlin
BOTTONE/BUTTON, 1967
Oil and sand on canvas, 66 3/4 x 51 1/8" / 170 x 130 cm
HAMBURGER KUNSTHALLE
p. 108
Photo: © Elke Walford, Hamburg
ROBERT GOBER
BURNT HOUSE, 1980
Wood, paint, corrugated board, metal, Plexiglas, linoleum, metal
screen, hinges, wheels, screws, 33 x 26 x 33 7/8",
83.8 x 66 x 86 cm
DAROS COLLECTION
p. 81
Photo: A. Burger, Zurich
UNTITLED (PILE OF NEWSPAPERS), 1990
Multiple 3/10, newspapers, 11 3/4 x 15 3/8 x 3 3/4" / 30 x 39 x 9.5 cm
COLLECTION RUDOLF AND UTE SCHARPFF, STUTTGART
UNTITLED (TORSO), 1991
Beeswax and human hair, 24 x 15 1/2 x 12" / 61 x 39.5 x 30.5 cm
SCHARPFF COLLECTION AT THE HAMBURGER KUNSTHALLE
p. 104
Photo: © Elke Walford, Hamburg
UNTITLED (WEDDING DRESS), 1992/93
Tinted gelatin silver print, 16 3/4 x 12 3/4" / 42.5 x 32.5 cm,
edition 1/15
SCHARPFF COLLECTION AT THE HAMBURGER KUNSTHALLE
p. 96
Photo: © Elke Walford, Hamburg
FELIX GONZALEZ-TORRES
UNTITLED (LOVERBOY), 1990
Blue fabric and metal rod, dimensions
vary with installation
HAMBURGER KUNSTHALLE
p. 109
Photo: Flavia Vogel
DOUGLAS GORDON
30 SECONDS TEXT, 1996
Vinyl text on black ground in dark room,
light bulb, timer, dimensions vary with installation,
maximum length of line 29 1/2" / 75 cm
GOETZ COLLECTION, MUNICH
DEAD LEFT, 1998
Color video, silent, 60 m., edition 3/3
GOETZ COLLECTION, MUNICH

p. 137
Photo: Courtesy Goetz Collection, Munich
DEAD RIGHT, 1998
Color video, silent, 60 m., edition 3/3
GOETZ COLLECTION, MUNICH
p. 137
Photo: Courtesy Goetz Collection, Munich
RICHARD HAMILTON
INTERIOR I, 1964
Oil, collage, cellulose on wood, 48 x 64" / 122 x 162.5 cm
KUNSTHAUS ZÜRICH, ERNA AND CURT BURGAUER COLLECTION
p. 57
Photo: Kunsthaus Zürich
JUST WHAT WAS IT THAT MADE YESTERDAY'S HOMES SO
DIFFERENT, SO APPEALING?, 1956/1991
Color laser print, the 1956 collage, electronically restored on a
Quantel Desktop Paintbox and printed directly from the computer
on a Canon CLC 500 printer on Mellotex paper by the artist.
Image: 10 5/16 x 9 7/8" / 26.2 x 25 cm,
sheet: 16 1/2 x 11 7/8" / 42 x 29.7 cm; edition 25, published by
Waddington Graphics, London
KUNSTMUSEUM WINTERTHUR, SWITZERLAND
GIFT OF DR. FRANK AND WILTRAUD RENTSCH, 1996
p. 64
Photo: Kunstmuseum Winterthur, Switzerland
JUST WHAT IS IT THAT MAKES TODAY'S HOMES SO
DIFFERENT?, 1994
Color laser print, collage elements acquired electronically from a
variety of sources. Image: 9 3/8 x 14 3/8" / 23.7 x 36.4 cm,
sheet: 11 7/8 x 16 1/2" / 29.7 x 42 cm. Edition 25, published by
Waddington Graphics, London
KUNSTMUSEUM WINTERTHUR, SWITZERLAND
GIFT OF DR. FRANK AND WILTRAUD RENTSCH, 1996
p. 63
Photo: Kunstmuseum Winterthur, Switzerland
DAVID HAMMONS
THE MASK, 1997
Wooden mask and glass beads, 29 7/8 x 17 3/8 x 9 1/2"
76 x 44 x 24 cm
COLLECTION FONDATION CARTIER
POUR L'ART CONTEMPORAIN, PARIS
p. 88
Photo: F. Kleinefenn
UNTITLED (STONE WITH HAIR), 1998
Stone, hair, can of shoe polish,
14 x 9 x 6" / 35.6 x 22.9 x 15.2 cm
COLLECTION FONDATION CARTIER
POUR L'ART CONTEMPORAIN, PARIS
p. 88
Photo: André Morin
DUANE HANSON
RIOT (POLICEMAN AND RIOTER), 1967
Polyester resin and fiberglass, polychromed in oil,
accessories, life-size
FLICK COLLECTION
p. 87
Photo: Ch. Schwager, Winterthur, Switzerland
HOUSEWIFE (HOMEMAKER), 1969/70
Mixed media, life-size
ONNASCH COLLECTION
p. 59
Photo: Courtesy Onnasch Collection
DAMIEN HIRST
WITH DEAD HEAD, 1991
Black-and-white photograph on aluminum,
22 1/2 x 29 7/8" / 57 x 76 cm
ZELLWEGER LUWA AG COLLECTION, USTER, SWITZERLAND
p. 85
Photo: Stephen White, Courtesy Jay Jopling, London
ALLAN KAPROW
ACTIVITY MODELS: TRANSFER, 1968/71
One of seven photographs from CALENDAR, 1968,

writing added 1971, 45¼ x 45¼" / 115 x 115 cm
HAMBURGER KUNSTHALLE
p. 73
Photo: © Elke Walford, Hamburg
ACTIVITY MODELS: MOVING, 1968/71
One of seven photographs from CALENDAR, 1968,
writing added 1971, 42⅛ x 42⅛" / 107 x 107 cm
HAMBURGER KUNSTHALLE
p. 73
Photo: © Elke Walford, Hamburg
ACTIVITY MODELS: TRAVELOG, 1968/71
One of seven photographs from CALENDAR, 1968,
writing added 1971, 41 x 47¼" / 104 x 120 cm
HAMBURGER KUNSTHALLE

KIM SOOJA (KIM SOO-JA)
CITIES ON THE MOVE–2727 KILOMETERS BOTTARI
TRUCK, 1997
Video installation of variable dimensions, showing the video pro-
duced in conjunction with the traveling performance CITIES ON
THE MOVE–2727 KILOMETERS BOTTARI TRUCK, which took place
for 11 days from Nov. 4th – 14th, 1997 in Korea. The global
project CITIES ON THE MOVE has been continued in other cities
and countries in the world using different media. Duration of video:
28'07"20, camera: Lee Sung Hwan, © Kim Sooja (Kim Soo-Ja),
1997, Korea
ART & PUBLIC, PIERRE HUBER, GENEVA
p. 89
Photo: Courtesy Art & Public, Pierre Huber, Geneva

YVES KLEIN
LE SAUT DANS LE VIDE/LEAP INTO THE VOID, 1960
In his newspaper *Dimanche, 27 Novembre*, 1960, the title read:
"Un homme dans l'espace! Le peintre de l'espace se jette
dans le vide!," 1960 (A man in space! The painter of space
throws himself into the void!)
REPRODUCTION (EXHIBITION COPY, 50 X 60 CM) OF THE PHOTOGRAPH
COURTESY OF YVES KLEIN ARCHIVES, PARIS
© YVES KLEIN ADAGP (for the work)
p. 77
Photo: Shunk-Kender, © Harry Shunk

JEFF KOONS
PINK BOW, 1996
Oil on canvas, 102 x 143" / 259.1 x 363.2 cm
SCHARPFF COLLECTION AT THE HAMBURGER KUNSTHALLE
p. 54
Photo: © Elke Walford, Hamburg
WOMAN IN TUB, 1988
Porcelain, 24⅜ x 35⅞ x 27⅛" / 62 x 91 x 69 cm
PRIVATE COLLECTION
p. 13
Photo: Jeff Koons Inc. Productions, New York

BARBARA KRUGER
I SHOP THEREFORE I AM, 1987
Photo silkscreen, 112 x 113" / 284.5 x 287 cm
PRIVATE COLLECTION, COURTESY THOMAS AMMANN FINE ART, ZURICH
p. 129
Photo: Courtesy Thomas Ammann Fine Art, Zurich

YAYOI KUSAMA
BLUE, 1960
Oil on canvas, 24 x 24" / 61 x 61 cm
COURTESY ROBERT MILLER GALLERY, NEW YORK
p. 116
Photo: © Yayoi Kusama, Courtesy Robert Miller Gallery, New York
COMPULSION FURNITURE, 1964
Photocollage, paint, 8 x 9⅞" / 20.4 x 25.1 cm
PHOTOGRAPH OF THE WORK (EXHIBITION COPY, 9⅞" x 11¾" / 25 x 30 cm)
COURTESY OTA FINE ARTS, TOKYO
p. 107
Photo: Courtesy Ota Fine Arts, Tokyo
SELF-OBLITERATION (NET OBSESSION SERIES), 1966
Photocollage, paint, 8 x 10" / 20.3 x 25.4 cm
PHOTOGRAPH OF THE WORK (EXHIBITION COPY, 9⅞" x 11¾" / 25 x 30 cm)
COURTESY OTA FINE ARTS, TOKYO

SHOE, 1976
Painted bronze, 8 x 9½ x 3¼" / 20.3 x 24.1 x 8.3 cm
COURTESY ROBERT MILLER GALLERY, NEW YORK
p. 107
Photo: © Yayoi Kusama, Courtesy Robert Miller Gallery, New York
REPETITIVE VISION, PHALLUS BOAT, 2000
Boat and fabrics, 137¾ x 59 x 31½" / 350 x 150 x 80 cm
CLAUDINE AND JEAN MARC SALOMON COLLECTION, COURTESY GALERIE
PIECE UNIQUE, PARIS
p. 98
Photo: Courtesy Galerie Pièce Unique, Paris

DAMIAN LOEB
DEEP SOUTH, 1999
Oil on linen, 72 x 72" / 182.9 x 182.9 cm
PRIVATE COLLECTION
p. 135
Photo: Courtesy Jay Jopling, London
ROSEVILLE, 1999
Oil on linen, 60 x 96" / 152.5 x 243.7 cm
RUDOLF AND UTE SCHARPFF COLLECTION, STUTTGART
pp. 142/143
Photo: Courtesy Jay Jopling, London

SARAH LUCAS
BUNNIE GETS SNOOKERED #11, 1997
Office chair, net stockings, nylon tights, kapok, wire, clamp
47¼ x 23⅝ x 41⅜" / 120 x 60 x 105 cm
HILDEBRANDT COLLECTION, HAMBURG
p. 82
Photo: Courtesy Hildebrandt Collection, Hamburg
PRIERE DE TOUCHER/PLEASE TOUCH, 2000
C-print, 30 x 20" / 76 x 51 cm, edition 1/10
ZELLWEGER LUWA AG COLLECTION, USTER, SWITZERLAND
Photo: © The Artist, Courtesy Sadie Coles HQ, London
SEX BABY, 2000
R-type-print, 36 x 24" / 91.5 x 61 cm, edition 7/10
ZELLWEGER LUWA AG COLLECTION, USTER, SWITZERLAND
p. 74
Photo: © The Artist, Courtesy Sadie Coles HQ, London

PIERO MANZONI
SOCLE DU MONDE/PLINTH OF THE WORLD, 1961
Iron, 32¼ x 39⅜ x 39⅜" / 82 x 100 x 100 cm
REPRODUCTION OF A PHOTOGRAPH OF THE WORK (50 X 60 CM)
HERNING KUNSTMUSEUM, DENMARK
p. 70
Photo: Thomas Pedersen and Poul Pedersen,
Herning Kunstmuseum, Denmark

ANA MENDIETA
RAPE SCENE, 1973
Suite of ten color slides documenting performance at Ana Men-
dieta's Apartment, Iowa, April 1973, series done as a reaction to
the rape of a student on the campus of the University of Iowa
ESTATE OF ANA MENDIETA AND GALERIE LELONG, NEW YORK
p. 75
Photo: Courtesy of the Estate of Ana Mendieta and Galerie Lelong, New York
PEOPLE LOOKING AT BLOOD, MOFFITT, IOWA, 1973
Suite of thirty-five color slides documenting the performance
in Moffitt, Iowa, May 1973
ESTATE OF ANA MENDIETA AND GALERIE LELONG, NEW YORK
p. 75
Photo: Courtesy of the Estate of Ana Mendieta and Galerie Lelong, New York

MAX MOHR
OHNE TITEL/UNTITLED, 2000
Metal, wood, fabric, orthopedic equipment, freezer,
nylon, silicon, dimensions vary with installation
COURTESY ARNDT & PARTNER, BERLIN
p. 99 (Frozen Paradise Prostheses, 1996)
Photo: Max Mohr

MARIKO MORI
KUMANO, 1997/98
Glass with photo interlayer, 120 x 240⅛ x ⅞",
305 x 610 x 2.16 cm, Edition of 3
ZELLWEGER LUWA AG COLLECTION, USTER, SWITZERLAND

pp. 118/119
Photo: Courtesy Deitch Projects, New York

BRUCE NAUMAN
MY NAME AS THOUGH IT WERE WRITTEN ON
THE SURFACE OF THE MOON, 1968
Neon tubing with clear glass suspension frame, in four parts,
11 x 204 x 2" / 27.9 x 518 x 5.1 cm
COLLECTION MIGROS MUSEUM FÜR GEGENWARTSKUNST, ZURICH
p. 156
Photo: Bruno Hubschmid, migros museum für Gegenwartskunst, Zurich
GET OUT OF MY MIND, GET OUT OF THIS ROOM
(ONE OF FIVE AUDIOTAPES IN THE SERIES STUDIO
AIDS II), 1968/69
Length: 6 m., continuous loop,
size of room: 120 x 145⅝ x 145⅝" / 305 x 370 x 370 cm
COLLECTION OF NELL & JACK WENDLER, LONDON

LOWELL NESBITT
STUDIO WINDOW I-III
(MORNING, NOON, EVENING), 1967
Oil on canvas, in three parts, each 79½ x 59½" / 202 x 151 cm
ONNASCH COLLECTION
p. 56
Photo: Courtesy Onnasch Collection

MERET OPPENHEIM
LE COUPLE/THE COUPLE, 1956
Leather and shoe laces, 7⅞ x 13¾ x 5⅞" / 20 x 35 x 15 cm
PRIVATE COLLECTION
p. 105
Photo: Courtesy D. Bürgi, Bern
DAS FRÜHLINGSFEST/THE SPRING BANQUET,
April 1959 in Bern
Laid out on the body of a nude woman
Black-and-white photograph, 9⅞" x 11¾" / 25 x 30 cm
PIRVATE COLLECTION, BERN
p. 23
Photo: Roland Aellig, Bern
X-RAY, 1964/81
Photograph after M.O.'s "X-RAY OF MY SKULL," 1964
Edition 2/20 of the 1981 edition
Paper: 16 x 12" / 40.5 x 30.5 cm, image: 9⅞ x 8⅛",
25 x 20.5 cm
GALLERY RENEE ZIEGLER, ZURICH
p. 147
Photo: Courtesy Renée Ziegler Gallery, Zurich

PAUL PFEIFFER
THE LONG COUNT (I SHOOK UP THE WORLD), 2000
Video installation (LCD monitor, metal armature,
digital video loop), dimensions vary with installation
COURTESY OF THE ARTIST AND THE PROJECT
p. 130
Photo: Paul Pfeiffer

SIGMAR POLKE
DAS GROSSE SCHIMPFTUCH
THE GREAT SCOLDING CLOTH, 1968
Tar on cotton sheeting, 157½ x 185" / 400 x 470 cm
DAROS COLLECTION
p. 72
DIE SCHERE/THE SCISSORS, 1982
Acrylic and glitter on fabric and canvas,
114⅛ x 114⅛" / 290 x 290 cm
RASCHDORF COLLECTION
p. 113
Photo: Wolfgang Morell Photo-Atelier, Bonn
URANGESTEIN (ROSA)/URANIUM ROCK (PINK), 1992
21 color enlargements of negatives exposed to radiation,
each 24 x 20" / 60.9 x 50.8 cm
RASCHDORF COLLECTION
p. 150 (Uranium Rock [Blue, Green, Violet], 1992)
Photo: Courtesy Anthony D'Offay Gallery, London

RICHARD PRINCE
UNTITLED (COWBOY), 1994

Ectacolor print, 48 x 72" / 122 x 183 cm, edition of 2
ZELLWEGER LUWA AG COLLECTION, USTER, SWITZERLAND
p. 53
Photo: Courtesy Zellweger Luwa AG Collection, Uster, Switzerland
UPSTATE, 1998
10 C-prints on ectacolor paper,
20 x 23⅞" / 50.7 x 60.8 cm each
Edition of 8
FALCKENBERG COLLECTION
p. 127
Photo: Klaus Auderer (photos showing women, couples),
Reger Studios Munich (photos of houses)
Courtesy Sabine Knust, Maximilian Verlag, Munich

GERHARD RICHTER/KONRAD LUEG
DEMONSTRATION FÜR DEN KAPITALISTISCHEN REALIS-
MUS / DEMONSTRATION OF CAPITALIST REALISM 1963,
at Möbelhaus Berges, Flingerstrasse 11, Berlin, third floor,
11th October 1963
1) Exhibition view: Gerhard Richter, reading a mystery, 2) Exhibi-
tion view: Konrad Lueg (left), Gerhard Richter (right), monitor
showing *News Program with Karl-Heinz-Köpcke*, 3) Visitors walk-
ing into the exhibition, Gerhard Richter (left), *Wardrobe with
Loan from Prof. Beuys on the Wall*
PHOTOGRAPHS (EXHIBITION COPIES, EACH 11⅞ x 15¾" / 30 x 40 cm)
FROM REINER RUTHENBECK
p. 76
Photo: © Reiner Ruthenbeck, Ratingen

BRIDGET RILEY
INTAKE, 1964
Acrylic on canvas, 69⅞ x 70½" / 177.5 x 179 cm
ONNASCH COLLECTION
p. 112
Photo: Friedrich Rosenstiel, Courtesy Onnasch Collection
EXPOSURE, 1966
Acrylic on canvas, 79⅞ x 159⅞" / 203 x 406 cm
ONNASCH COLLECTION
pp. 114/115
Photo: Courtesy Onnasch Collection

PIPILOTTI RIST
MUTAFLOR, 1996
Video installation (1 projector, 1 player, silent), dimensions
vary with installation
THE ARTIST AND HAUSER & WIRTH GALLERY, ZURICH
p. 102
Photo: Alexander Troehler, courtesy of the artist and
Hauser & Wirth Gallery, Zurich
I COULDN'T AGREE WITH YOU MORE, 1999
Video installation (2 projectors, 2 players, 1 audio system,
sound: Anders Guggisberg), dimensions vary with installation
THE ARTIST AND HAUSER & WIRTH GALLERY, ZURICH
p. 58
Photo: Alexander Troehler, courtesy of the artist and
Hauser & Wirth Gallery, Zurich

MATTHEW RITCHIE
ABRAXAS, 2000
Oil and marker on canvas, 62 x 90" / 157.5 x 228.6 cm
HAMBURGER KUNSTHALLE
GIFT OF THE BALOISE VERSICHERUNGS-GRUPPE
p. 155
Photo: © Elke Walford, Hamburg

JAMES ROSENQUIST
I LOVE YOU WITH MY FORD, 1961
Oil on canvas, 82¾ x 93½" / 210 x 237.5 cm
MODERNA MUSEET, STOCKHOLM
p. 49
Photo: Moderna Museet, Stockholm
SAUCE, 1967
Oil on slit polyester film (mylar), 114 x 70⅞" / 289.6 x 180 cm
PRIVATE COLLECTION, COURTESY 1000 EVENTI GALLERY, MILAN, ITALY
p. 55
Photo: Filippo Valfrè di Bonzo, courtesy 1000 Eventi Gallery, Milan

FOR LAO TSU, 1968
Oil on polyester film (mylar), 118⅛ x 118⅛ x 78¾" / 300 x 300 x
200 cm
MARIELLA COLLECTION, GENOA, ITALY
p. 139
Photo: Courtesy 1000 Eventi Gallery, Milan

MARTHA ROSLER
BRINGING THE WAR HOME, 1967-72
From a series of 20 photomontages, 19¹¹⁄₁₆ x 23⅝" /
50 x 60 cm or 23⅝ x 19¹¹⁄₁₆" / 60 x 50 cm, edition of 10
FALCKENBERG COLLECTION
pp. 67, 86
Photo: Collection Generali Foundation, Vienna and Archive Martha Rosler

NIKI DE SAINT PHALLE
JEAN TINGUELY
PER OLOF ULTVEDT
HON - EN KATEDRAL
SHE - A CATHEDRAL, 4th June - 4th September, 1966
Exhibition at the Moderna Museet, Stockholm
PHOTOGRAPHS OF THE EXHIBITION (EACH 19¾ x 27½" / 50 x 70 cm)
FROM HANS HAMMARSKIÖLD
p. 71
Photo: © Hans Hammarskiöld, Lidingö, Sweden

BEN SCHONZEIT
HOUSE (BLOWN AWAY), 1975
Acrylic on canvas, 98⅜ x 65½" / 250 x 166.5 cm
HAMBURGER KUNSTHALLE
p. 80
Photo: © Elke Walford, Hamburg

CINDY SHERMAN
UNTITLED, 1999
Black-and-white photograph, image: 47½ x 31½",
120.6 x 80 cm; framed: 55½ x 39½" / 141 x 100.3 cm
OLBRICHT COLLECTION
p. 101
Photo: Courtesy of the artist and Metro Pictures, New York
UNTITLED, 1999
Black-and-white photograph, image: 38½ x 25½",
97.8 x 64.8 cm; framed: 46½ x 33½" / 118.1 x 85 cm
OLBRICHT COLLECTION
UNTITLED/OHNE TITEL, 1999
Black-and-white photograph, image: 21½ x 32½",
54.6 x 82.6 cm; framed: 29½ x 40½" / 75 x 102.9 cm
OLBRICHT COLLECTION
p. 101
Photo: Courtesy of the artist and Metro Pictures, New York
UNTITLED, 1999
Black-and-white photograph, image: 35½ x 23½",
90.2 x 59.7 cm; framed: 43½ x 31½" / 110.5 x 80 cm
OLBRICHT COLLECTION
p. 101
Photo: Courtesy of the artist and Metro Pictures, New York

DIRK SKREBER
OHNE TITEL (ULTRA VIOLENCE)
UNTITLED (ULTRA VIOLENCE), 1999
Oil on canvas, 66⅞ x 90½" / 170 x 230 cm
OLBRICHT COLLECTION
p. 131
Photo: Courtesy Luis Campaña Gallery, Cologne

FRED TOMASELLI
BUG BLAST, 1998
Pills, leaves, insects, photocopies, acrylic, resin on
wood panel, 60 x 60" / 152 x 152 cm
COURTESY ANNE DE VILLEPOIX GALLERY, PARIS
NEW JERUSALEM, 1998
Pills, leaves, insects, photocollage, acrylic,
resin on wood panel, 60 x 60" /152 x 152 cm
COURTESY ANNE DE VILLEPOIX GALLERY, PARIS
p. 118
Photo: Courtesy Anne de Villepoix Gallery, Paris
STUDY FOR BUTTERFLY EFFECT, 1999
Aspirin, photocopies, acrylic, resin on wood panel,

24 x 30" / 61 x 76.2 cm
PRIVATE COLLECTION
p. 111
Photo: Courtesy Gebauer Gallery, Berlin

JEFF WALL
THE GIANT, 1992
Cibachrome transparency, fluorescent light, display case,
19½ x 23 x 4¾" / 49.5 x 58.4 x 12 cm, edition of 8
ZELLWEGER LUWA AG COLLECTION, USTER, SWITZERLAND
p. 138
Photo: Courtesy Marian Goodman Gallery, New York
INSOMNIA, 1994
Cibachrome transparency, fluorescent light,
display case, 76 x 91¾" / 193 x 233 cm
HAMBURGER KUNSTHALLE
p. 126
Photo: © Elke Walford, Hamburg

JANE AND LOUISE WILSON
STASI CITY, 1996
Video installation, 4 screen laser disk projection,
room size ca. 8 x 8 x 4 m
F. UND W. STIFTUNG FÜR ZEITGENÖSSISCHE KUNST AT THE
HAMBURGER KUNSTHALLE
p. 83
Photo: Courtesy Lisson Gallery, London

Sources of quotations in the Hypermental "newspaper"

■ **Annan, Kofi.** Quoted from: Yves Marignac. Ein Sarkophag für die Atomindustrie. In: *Le Monde diplomatique* (German edition). Paris, July 2000.*

■ **Baldwin, James/Mead, Margaret.** *A Rape on Race.* Dell Publishing, New York 1971, pp. 57-58.

■ **Ballard, J.G.** Project for a Glossary of the Twentieth Century. In: *Zone*, n° 6, New York 1992, pp. 269, 273, 279.

■ **Barthes, Roland.** *Mythologies.* New York 1972, pp. 37-38, 98-99.

■ **Bataille, Georges.** *L'Expérience Intérieure.* Éditions Gallimard, Paris 1957, pp. 122, 130 - 131.*

■ **Baudrillard, Jean.** Das Orbitale und das Nukleare. In: *Agonie des Realen* (first published as: *La précession des simulacres*). Merve Verlag / Traverses 10, Berlin / Paris 1978.*

■ **Betsky, Aaron.** *Magnets of Meaning* (exh. cat.: Museum of Modern Art, San Francisco 18 April - 5 August 1997). Chronicle Books, San Francisco 1997, p. 40 - 41, 126.

■ **Bohr, Niels.** Atoms and Human Knowledge (1955). In: *Essays 1932-1957 on Atomic Physics and Human Knowledge.* Friedr. Ox Bow Press, Woodridge, Connecticut 1987, p. 88.

■ **Bonfadelli, Heinz.** Wirklicher als die Wirklichkeit? In: *Tages-Anzeiger*, Zurich, 30 November 1999.*

■ **Bourgeois, Louise.** In: Meyer-Thoss, Christiane. *Louise Bourgeois. Konstruktionen für den freien Fall.* Ammann Verlag, Zurich 1992, pp. 178, 181, 200.

■ **Bove, Emmanuel.** *Meine Freunde* (first published 1924 as: *Mes Amis*). Suhrkamp Verlag / Flammarion, Frankfurt a. M. / Paris 1981 / 1977, p. 111.*

■ **Burden, Chris.** Untitled Statement (1975). In: Butterfield, Jane. Chris Burden: Through the Night Softly. In: Arts 49, n°7 (March 1975), pp. 68 - 72.

■ **Burroughs, William S.** The Invisible Generation (1966). In: *Electronic Revolution.* Expanded Media Ed., Bonn 1970, p. 21.

■ **Burroughs, William S.** *Naked Lunch.* Olympia Press, Paris 1959, p. 32.

■ **Burroughs, William S.** *The Wild Boys. A Book of the Dead.* Calder & Boyars Ltd., London 1972, pp. 40 - 42.

■ **Butler, Judith.** *Gender Trouble.* Routledge, New York 1990, p. 24.

■ **Caufield, Catherine.** *Multiple Exposures - Chronicles of the Radiation Age.* The University of Chicago Press, Chicago 1989, p. 193.

■ **Clarke, Arthur C. / Kubrick, Stanley.** *2001 - A Space Odyssey.* London 1968, pp. 246, 248.

■ **Croal, N'Gai.** The Art of the Game. In: *Newsweek*, New York, 6 March 2000.

■ **Dali, Salvador.** *Meine Leidenschaften* (first published as: *Les Passions selon Dali*). Ferenczy Verlag / Editions Denoël, Paris 1968, p. 139.*

■ **Debord, Guy.** *The Society of the Spectacle* (first published as: *La Société du Spectacle*). Rebel Press / Éditions Buchet-Chastel, London / Paris 1992 / 1967, pp. 64 - 66.

■ **Deleuze, Gilles and Guattari, Félix.** *Anti-Oedipus* (first published as: *Anti-Œudipe*). The Athlone Press / Les Éditions de Minuit, London / Paris 1984 / 1974, pp. 351, 352.

■ **Deuber-Mankowsky, Astrid.** Lara Crofts Heilsversprechen. In: *Die Wochenzeitung*, Zurich, 10 August 2000.*

■ **Dick, Philip K.** *Do Androids Dream of Electric Sheep?* Doubleday Inc., New York 1968, p. 5.

■ **Duchamp, Marcel.** Rrose Sélavy (1965/66). In: Moure, Gloria (ed.). *Marcel Duchamp* (exh. cat.: Museum Ludwig, Cologne 27 June - 19 August 1984). Museen der Stadt Köln 1984, p. 202.

■ **Duchamp, Marcel.** Where do we go from here? (1961). In: Cabanne, Pierre (ed.). *Dialogues with Marcel Duchamp.* Thames and Hudson, London 1971, pp. 64 -65.

■ **Eco, Umberto.** Travels in Hyperreality (1975). In: *Faith in Fakes* (first published as: *Dalla periferia dell'imperio*). Secker & Warburg / Editoriale Fabbri-Bompiani, London / Milano 1986 / 1977, p. 43.

■ **Eco, Umberto.** *Apocalittici e integrati.* Editoriale Fabbri-Bompiani, Milano 1964, pp. 227-228 (for this excerpt translation in English by Richard Michell).

■ **Export, Valie.** Weiberleiber. In: *Forum* Nr. 413/414, 1988, pp. 10 - 13.*

■ Forscher legt neue Bigfoot-Theorie vor. In: *20 minuten*, Zurich, 19 July 2000.*

■ **Foster, Hal.** *The Return of the Real.* MIT Press, New York and Cambridge Mass. 1996, p. 145.

■ **Foucault, Michel.** An Interview with the magazine QUEL CORPS? (Sept. - Oct. 1975). In: Kamper, Dietmar / Rittner, Volker (ed.). *Zur Geschichte des Körpers.* Carl Hanser Verlag, Munich and Vienna 1976, p. 132 - 133.*

■ **Foucault, Michel.** *The History of Sexuality, An Introduction* (first published as: *Histoire de la sexualité, 1: La volonté de savoir*). Penguin Books / Gallimard, London / Paris 1981 / 1976, pp. 43 - 44.

■ **Freitas jr., Robert A. K.** Eric Drexler. In: *Frankfurter Allgemeine Zeitung*, 18 September 2000.*

■ **Georgen, Roman.** Prinzessin Diana und die Mythen-Konjunktur. In: *Neue Zürcher Zeitung*, Zurich, 10 February 1998.*

■ **Gibson, William.** *Neuromancer.* HarperCollins, London 1984, p. 51.

■ **Godard, Jean-Luc.** *Histoire(s) du Cinéma.* ECM Records, Munich 1999, p. 24 / vol. 4.

■ **Goetz, Rainald.** *Abfall für alle. Roman eines Jahres.* Suhrkamp Verlag, Frankfurt a. M. 1999, p. 863.*

■ **Grant, Carry.** In: Giacobbe, Alyssa. July-Calendar - ELLE's guide to an eventful month. In: *ELLE*, July 2000, p. 26.

■ **Guinness World Records 2000.** Millennium Edition 1999, p. 31, 51.

■ **Hamilton, Richard.** NOT SEEN and / or LESS SEEN of / by MARCEL DUCHAMP / RROSE SELAVY (1965). In: *Catalogue of the Mary Sisler Collection 1904 - 1964.* Cordier & Ekstrom Inc., New York 1965.

■ **Handke, Peter.** *Offending the Audience.* Methuen & Co, London 1971, p. 18.

■ **Haraway, Donna.** A Cyborg Manifesto. In: *Simians, Cyborgs, and Women - The Reinvention of Nature.* Routledge Ed., New York 1991, pp. 150, 180.

■ **Heller, Richard.** Ein Mann vermöbelt die Welt. In: *Bilanz*, Zurich, September 2000.*

■ **Herzinger. Richard.** Die wirklichere Wirklichkeit. In: *Die Zeit*, Hamburg, 18 May 2000.*

■ "Keiko" virtuell ermordet. In: *Metropol*, Zurich, 20 July 2000.*

■ **Huxley, Aldous.** *The Doors of Perception.* Chatto & Windus, London 1954, p. 18. Copyright © Piper Verlag GmbH, München

■ **International** Nuclear Safety Advisory Group (ed.). *Summary Report on the Post-Accident Review Meeting on the Chernobyl Accident.* International Atomic Energy Agency (IAEA), Vienna 1986, p. 53.

■ **Jolles, Claudia.** Interview mit Erik Bulatov und Ilya Kabakov, Moskau, Juli 1987. In: *Erik Bulatov. Moskau.* Parkett Verlag und Kunsthalle, Zurich 1988, p. 41.

■ **Kellein, Thomas.** *Sputnik-Schock und Mondlandung.* Gerd Hatje Verlag, Stuttgart 1989, p. 69.*

■ **Kennedy, John F.** A Special Message to Congress. In: *New York Times*, 26 May 1961, p. 12.

■ **Kimmelman, Michael.** Modern Op - Bridget Riley was Op Art's That Girl in the 1960s. In: *The New York Times Magazine*, 27 August 2000.

■ **Koons, Jeff.** *The Jeff Koons Handbook.* Anthony d'Offay Gallery & Schirmer / Mosel, London & Munich 1992, p. 33.

■ **Koule, Léopold.** Les filles terribles. In: *Max*, August 2000.

■ **Krauss, Rosalind.** *The Optical Unconscious.* MIT Press, Cambridge, Mass. 1993, p. 172.

■ **Kristeva, Julia.** *Strangers to Ourselves* (first published as: *Etrangers à nous mêmes*). Harvester Weatsheaf / Librairie Arthème Fayard, London / Paris 1991 / 1988, p. 7.

■ **Kruger Barbara.** Remote Control (1986). In: Wallis, Brian (ed.). *Blasted Allegories.* New Museum of Contemporary Art and MIT Press, Cambridge, Mass. 1987, p. 397.

■ **Kuipers, Dean / Aitken, Doug.** *I Am a Bullet.* Crown Publishers and 303 Gallery, New York 2000.

■ **Lawson, Thomas.** Nostalgia As Resistance. In: Institute of Contemporary Art London (ed.). *Modern Dreams: The Rise and Fall and Rise of Pop.* ICA and MIT Press, New York and Cambridge, Mass. 1988, p. 60.

■ **Leary, Timothy.** *Chaos & Cyber Culture.* Ronin Publishing Inc, Berkeley 1994, pp. 44, 47.

■ **Levy, Steven.** Here Comes PlayStation 2. In: *Newsweek*, New York, 6 March 2000.*

■ **Lyotard, Jean-François.** German press release of the exhibition *Les Immatériaux.* Beaubourg (Paris) 28 May - 15 July 1985.*

■ **Magnum**, n° 11, Dezember 1956. Quoted in: Kellein, Thomas. *Sputnik-Schock und Mondlandung.* Gerd Hatje Verlag, Stuttgart 1989, p. 69.*

■ **Manzoni, Piero.** For the Discovery of a Zone of Images (1957). In: Stiles, Kristine / Selz, Peter (eds.). *Theories and Documents of Contemporary Art.* University of California Press, Berkeley 1996, p. 80.* Copyright © 1996 The Regents of the University of California.

■ **Marcus, Greil.** The Elvis Test. In *San Francisco Examiner and Chronicle*, San Francisco, 17 January 1993, pp. 8, 10.

■ **McLuhan, Marshall.** *Understanding Media: The Extensions of Man.* McGraw-Hill Paperback Ed., New York 1964, p. 18.

■ **Merleau-Ponty, Maurice.** *Phenomenology of Perception* (first published as: *Phénoménologie de la perception*). Routledge & Kegan Paul / Éditions Gallimard, New York / Paris 1992 / 1945, pp. 261 - 262.

■ **Miller, Henry.** The Brooklyn Bridge (1941). In: *The Cosmological Eye.* Editions Poetry, London 1945, pp. 343 - 344.

■ **Miller, Henry.** *Tropic of Cancer.* Obelisk Press, Paris 1934, p. 195.

■ **Minkmar, Nils.** Das gedopte Magazin. In: *DIE ZEIT*, Hamburg, 25 May 2000.*

■ **Müller, Thomas.** Eine lange Suche nach Leben auf dem Mars. In: *Tages-Anzeiger*, Zurich, 8 August 1996.*

■ **Muschg, Konrad.** In den virtuellen Vierteln von Tokio. In: *Tages-Anzeiger*, Zurich, 22 June 2000.*

■ **Naso, P. Ovidius.** *The Metamorphoses of Ovid.* Penguin Books, London 1955, p. 231.

■ **New York Sun,** 6. 1. 1896. Quoted in: Caufield, Catherine. *Multiple Exposures – Chronicles of the Radiation Age.* The University of Chicago Press, Chicago 1989, p. 4.

■ Radio Listeners in Panic, Taking War Drama as Fact. In: **The New York Times,** 30 October 1938.*

■ **Packard, Vance.** *The Hidden Persuaders.* David McKay Company, New York 1957, pp. 66 – 67.

■ **Perry, Nick.** Hyperreality and Global Culture. Routledge Ed., New York 1998, p. 37.

■ **Piotrowski, Christa.** Pubertäre Sprüche statt anspruchsvoller Humor. In: *Neue Zürcher Zeitung*, Zurich, 6 February 1998.*

■ **Postman, Neil.** *Amusing Ourselves to Death. Public Discourse in the Age of Show Business.* Viking-Penguin, New York 1985, p. 24.

■ **Prince, Richard.** *War Pictures.* CEPA Gallery Buffalo, N.Y., February 1980.

■ **Reed, Lou.** Walk On The Wild Side. Album: *Transformer.* RCA 1972.

■ **Ritchie, Matthew.** *The Fast Set* (exn. cat.: Museum of Contemporary Art, North Miami, 31 March – 25 June 2000). North Miami 2000, p. 9.

■ **Rötzer, Florian.** Wissenschaft und Ästhetik. In: *Kunstforum International*, vol. 124, November - December 1993, p. 75.*

■ **Sartre, Jean-Paul.** Der Krieg und die Angst oder Mit der Gefahr eines Atomkriegs leben (first published as: *La guerre et la peur*), 1946. In: König, Traugott (ed.). *Sartre Lesebuch. Den Menschen erfinden.* Rowohlt Verlag / Gallimard, Reinbek bei Hamburg / Paris 1986 / 1970, pp. 77 - 78.*

■ **Schultz, Irmgard.** Madonna - das ewige und das wirkliche Idol. In: Akashe-Böhme, Farideh (ed.). *Reflexionen vor dem Spiegel.* Suhrkamp Verlag, Frankfurt a. M. 1992, pp. 106-107.*

■ **Searle, John R.** I Married a Computer. In: New York *Review of Books*, New York, 8 April 1999.

■ **Seitz, William C.** *The Responsive Eye* (exh. cat.: The Museum of Modern Art, New York 1965). MoMA 1965, pp. 30-31, 43.

■ **Sloterdijk, Peter.** *Blasen.* Suhrkamp Verlag, Frankfut a. M. 1998, pp. 72 - 74.*

■ **Stadelmaier, Gerhard.** $X^n + Y^n = Z^n$. In: *Frankfurter Allgemeine Zeitung*, Frankfurt, 6 June 2000.*

■ **Teipel, Jürgen.** Ehrlich geklaut. In: *DIE ZEIT*, Hamburg, 31 May 2000.*

■ **Theweleit, Klaus.** *Ghosts: Drei leicht inkorrekte Vorträge.* Stroemfeld Verlag, Frankfurt a. M. / Basel 1998, pp. 137 - 138.*

■ **Vidal, Gore.** West Point (1973) *Matters of Fact and of Fiction.* Heinemann, London 1977, p. 198.

■ **Volkart, Yvonne / Sollfrank, Cornelia.** *Next Cyberfeminist International.* Rotterdam, March 8 – 11, 1999. Old Boys Network, Hamburg 1999, p. 5.

■ **Vostell, Wolf.** Happening Manifesto, New York, 26. 3. 1966. In: Block, René. *Graphik des Kapitalistischen Realismus.* Stolpe Verlag, Berlin 1968, p. 21.*

■ **Wall, Jeff.** The Interiorized Academy - Interview with Jean François Chevrier (1990). In: de Duve, Thierry / Pelenc, Arielle / Groys, Boris (eds.). *Jeff Wall.* Phaidon Press Unlimited, London 1996, p. 104.

■ **Walton, John / Beeson, Paul B (eds.).** *Oxford Companion to Medicine,* vol. II. Oxford University Press, Oxford 1986, pp. 1004, 1037.

■ **Warwick, Kevin.** Cyborg 1.0. In: *Wired*, San Francisco, February 2000, pp. 146, 148.

■ **Wegen** einer Brille erstochen. dpa, 16 February 1984. Quoted in: Deutscher Werkbund e.V. und Württembergischer Kunstverein (ed.). *Schock und Schöpfung.* Hermann Luchterhand Verlag, Darmstadt und Neuwied 1986, p. 178.*

■ **Widmer, Urs.** Sind die Frauen einfach schlauer. In: *Tages-Anzeiger*, Zurich, 22 July 2000.*

■ **Žižek, Slavoj.** Enjoy! Als die Ideologien gingen, kam der Lifestyle. In: *DIE ZEIT*, Hamburg, 19 July 1999.*

All headlines invented by the editors.
* **Translated from the German by Catherine Schelbert**

Contributors

Sibylle Berg writes for several journals including *Das Magazin (Tages-Anzeiger), Stern, Geo, Merian, Allegra,* and *Die Woche.* Her fourth novel, *Gold,* will be published this fall by Hoffmann und Campe.

Norman Bryson is Chair of the History and Theory of Art at the Slade School of Fine Art, University College, London. His publications include: *Vision and Painting: The Logic of the Gaze* (Yale University Press, New Haven/London, 1986); *Looking at the Overlooked: Four Essays on Still Life Painting* (Harvard University Press, Cambridge MA, 1991). He is general editor of: *Visual Culture: Images of Interpretation* (University Press of New England, Hanover NH, 1994); *Cambridge Studies in New Art History & Criticism* (Cambridge University Press, Cambridge), and together with Homi Bhabha and Wu Hung co-editor of the series *Envisoning Asia* (Reaktion Books, London).

Bice Curiger is editor-in-chief of *Parkett* magazine and a curator of the Kunsthaus Zürich. She is the author of the monograph *Meret Oppenheim, Defiance in the Face of Freedom* (MIT Press, Cambridge, MA, 1989) and has published numerous essays on Sigmar Polke. Curatorial projects include *Birth of the Cool, American Painting from Georgia O'Keeffe to Christopher Wool*, Kunsthaus Zürich and Deichtorhallen Hamburg, 1997; *Doubletake* (with Lynne Cooke and Greg Hilty), Hayward Gallery, London, 1992.

Paul D. Miller is a conceptual artist, writer, and musician working in NYC. Miller is best known under the moniker of his "constructed persona" as "DJ Spooky that Subliminal Kid," a character from his upcoming novel *Flow My Blood the DJ Said* that uses a wide variety of digitally created music as a form of postmodern sculpture. His written work has appeared in *The Village Voice, The Source, Artforum, Raygun, Rap Pages, Paper Magazine,* etc. He is also Editor-At-Large of the digital media magazine *Artbyte: The Magazine of Digital Culture.* Paul D. Miller can be found at www.djspooky.com

Griselda Pollock is Professor of Social and Critical the Histories of Art at University of Leeds and Director of the Graduate Programme (M.A./Ph.D) in Feminist Theory and the Visual Arts. Recent Books include Griselda Pollock, Rozsika Parker (eds.), *Framing Feminism: Art and the Women's Movement, 1970-1985* (Pandora Books, London, 1987); *Vision and Difference: Femininity, Feminism and the Histories of Art* (Routledge, London, 1988); *Avant-Garde Gambits: Gender and the Colour of Art History* (Thames, London, 1992); *Generations and Geographies in the Visual Arts: Feminist Readings* (1996) as well as sowie *Differencing the Canon: Feminist Desire and the Writing of Art Histories* (1999), both Routledge, London/New York.

Gero von Randow is a science journalist and has worked as editor of various departments at the weekly newspsaper *Die Zeit,* Hamburg, since 1992; he is currently deputy editor of the political section. He has published books on mathematics, computer sciences, and robotics (*Roboter. Unsere nächsten Verwandten,* Rowohlt, Reinbek b. Hamburg, 1997). His latest book, to be published in Spring 2001 by Hoffmann und Campe, explores the facets of enjoyment.

Peter Weibel is Chairman and Chief Executive Officer of the ZKM, Zentrum für Kunst und Medientechnologie in Karlsruhe. Recent publications include: *Offene Handlungsfelder. Open Practices. Prassi aperta,* Austrian Pavilion, 45. Venice Biennale (DuMont, Cologne, 1999); Peter Weibel (ed.), *Kunst ohne Unikat. Techno Transformationen der Kunst* (W. König Verlag, Cologne, 1999); Rainer Burkhard, Wolfgang Maas and Peter Weibel (eds.), *Zur Kunst des formalen Denkens* (Passagen Kunst. Perspektiven einer Wissenschaftskultur in Österreich, Vienna, 2000); Peter Weibel and Timothy Druckrey (eds.), *net_condition. art and global media* (MIT Press, Cambridge, MA, 2000).